IMAGES
of America

CAMP ABBOT

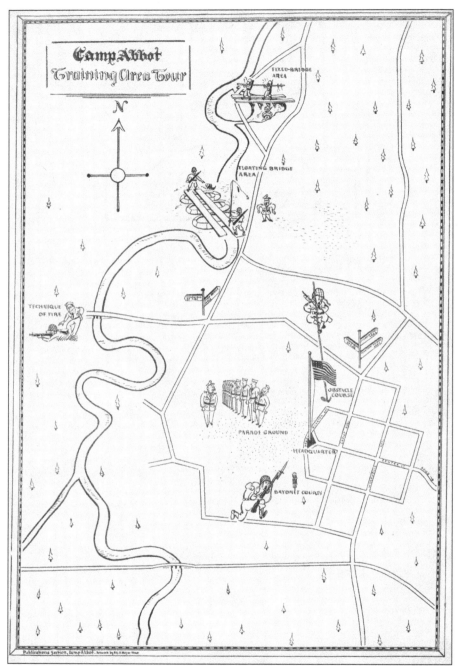

This map of Camp Abbot was produced by the publications section at Camp Abbot. Artwork was done by Pvt. H. Meyer-Trave. (Courtesy of Deschutes Historical Museum.)

ON THE COVER: Four Camp Abbot combat engineers are moving a pneumatic pontoon across the fast-flowing Deschutes River with the help of an anchor wire crossing the river. (Courtesy of US Army Signal Corps.)

IMAGES
of America

CAMP ABBOT

Tor Hanson

ARCADIA
PUBLISHING

Published by Arcadia Publishing
Charleston, South Carolina

Library of Congress Control Number: 2018932486

For all general information, please contact Arcadia Publishing:
Telephone 843-853-2070
Fax 843-853-0044
E-mail sales@arcadiapublishing.com
For customer service and orders:
Toll-Free 1-888-313-2665

Visit us on the Internet at www.arcadiapublishing.com

This book is dedicated to my wife and first reader,
Nancy. You are my true north. Jag älskar dig!

CONTENTS

Acknowledgments 6

Introduction 7

1. Building Camp Abbot 9

2. Basic Training 21

3. Specialist Training 37

4. Field Training Problem 55

5. The Oregon Maneuver 67

6. Living at Camp Abbot 75

7. On the Home Front 91

8. Building the Officers' Mess 99

9. Closing Camp Abbot 109

10. Sunriver and Camp Abbot's Legacy 113

Bibliography 126

Index 127

ACKNOWLEDGMENTS

Many months ago, my good friend, mentor, and fellow writer Les Joslin approached me about producing an Images of America series book about Camp Abbot. I had previously helped Les with scanning pictures for his two Arcadia Publishing books, *Legendary Locals of Bend* and Images of America: *Deschutes National Forest*. He handed me his file of Camp Abbot research materials and told me about a cache of US Army Signal Corps photographs once stored at the Sunriver Nature Center. It was the beginning of a long scavenger hunt to locate photographs of a US Army Corps of Engineers training program that took place more than 75 years ago. We finally managed to track down over 450 photographs generated by Army photographers and soldiers stationed at Camp Abbot.

There are several people I want to thank for their help in locating material for this book. Carolyn Maxwell at Sunriver Nature Center supplied me with a flash drive containing over 200 digital scans of US Army Signal Corps photographs. Jayne Bristow at Sunriver Lodge gave me access to the lodge's holdings of additional Army photographs that added to the digital collection. Kelly Cannon-Miller, executive director of the Deschutes County Historical Society, provided me access to the Halliburton Collection, which is a part of the Deschutes Historical Museum's holdings.

Writing is said to be a lonely business, but I have to admit that I have never felt that way. Over the course of this project, I have had good company along the way. My wife, Nancy, has been my first reader and copy editor on so many of my writing projects. I trust her when she says, "This does not make sense." Les has been my sounding board and editor who has spared me embarrassing errors.

Unless otherwise noted, the photographs in this book are used courtesy of the US Army Signal Corps. Images courtesy of the Deschutes Historical Museum are credited as DHM throughout the text.

Finally, I salute the men and women who served in the armed forces of the United States during the largest armed conflict of the 20th century.

IMAGES
of America

CAMP ABBOT

Tor Hanson

ARCADIA
PUBLISHING

Published by Arcadia Publishing
Charleston, South Carolina

Library of Congress Control Number: 2018932486

For all general information, please contact Arcadia Publishing:
Telephone 843-853-2070
Fax 843-853-0044
E-mail sales@arcadiapublishing.com
For customer service and orders:
Toll-Free 1-888-313-2665

Visit us on the Internet at www.arcadiapublishing.com

*This book is dedicated to my wife and first reader,
Nancy. You are my true north. Jag älskar dig!*

CONTENTS

Acknowledgments 6

Introduction 7

1. Building Camp Abbot 9

2. Basic Training 21

3. Specialist Training 37

4. Field Training Problem 55

5. The Oregon Maneuver 67

6. Living at Camp Abbot 75

7. On the Home Front 91

8. Building the Officers' Mess 99

9. Closing Camp Abbot 109

10. Sunriver and Camp Abbot's Legacy 113

Bibliography 126

Index 127

ACKNOWLEDGMENTS

Many months ago, my good friend, mentor, and fellow writer Les Joslin approached me about producing an Images of America series book about Camp Abbot. I had previously helped Les with scanning pictures for his two Arcadia Publishing books, *Legendary Locals of Bend* and Images of America: *Deschutes National Forest*. He handed me his file of Camp Abbot research materials and told me about a cache of US Army Signal Corps photographs once stored at the Sunriver Nature Center. It was the beginning of a long scavenger hunt to locate photographs of a US Army Corps of Engineers training program that took place more than 75 years ago. We finally managed to track down over 450 photographs generated by Army photographers and soldiers stationed at Camp Abbot.

There are several people I want to thank for their help in locating material for this book. Carolyn Maxwell at Sunriver Nature Center supplied me with a flash drive containing over 200 digital scans of US Army Signal Corps photographs. Jayne Bristow at Sunriver Lodge gave me access to the lodge's holdings of additional Army photographs that added to the digital collection. Kelly Cannon-Miller, executive director of the Deschutes County Historical Society, provided me access to the Halliburton Collection, which is a part of the Deschutes Historical Museum's holdings.

Writing is said to be a lonely business, but I have to admit that I have never felt that way. Over the course of this project, I have had good company along the way. My wife, Nancy, has been my first reader and copy editor on so many of my writing projects. I trust her when she says, "This does not make sense." Les has been my sounding board and editor who has spared me embarrassing errors.

Unless otherwise noted, the photographs in this book are used courtesy of the US Army Signal Corps. Images courtesy of the Deschutes Historical Museum are credited as DHM throughout the text.

Finally, I salute the men and women who served in the armed forces of the United States during the largest armed conflict of the 20th century.

INTRODUCTION

After the December 7, 1941, attack on Pearl Harbor caused the United States to enter World War II, the US Army began an unprecedented buildup to fight a war on two fronts: the European and the Pacific. The Army had training facilities all over the country, and its Corps of Engineers already ran two engineer replacement training centers (ERTC) at Fort Belvoir, Virginia, and Fort Leonard Wood, Missouri, both east of the Mississippi River. In 1942, Brig. Gen. Clarence Sturdevant proposed the opening of a third ERTC facility located near the West Coast.

The primary mission of the ERTC—reflected in the word "replacement"—was to train individual soldiers as replacements for combat engineers wounded or killed in action rather than as members of units to be sent to the front.

Building the third ERTC began in June 1942, when Col. Richard Park was notified to start looking for a location suitable for such a project. Colonel Park, who was division engineer for the North Pacific Division with headquarters in Portland, was familiar with Bend and the Central Oregon area.

After scouting the area in detail, Colonel Park selected the Shonquest Ranch, other adjacent private holdings, and surrounding Deschutes National Forest lands as a possible site for the new installation and training grounds. The plans to invade "Fortress Europe" were at an advanced stage in Washington, DC, and the Central Oregon landscape was thought to be similar to the terrain in France and Germany. The swift-flowing Deschutes River also held promise of simulating German rivers for the training of combat engineers.

The local engineering division initially approved the proposal, and construction plans were formulated. The proposal was sent up the chain of command, and in October 1942, the project was approved by officials in Washington, DC.

On Election Day, November 3, 1942, only days before Armistice Day on November 11, the local newspaper, *The Bend Bulletin*, carried a front-page article titled, "Army Camp is Announced for Bend."

Bend, the seat of Deschutes County, had a population of about 10,000. Now, the Army was planning to build a similar-sized city only 15 miles from Bend. The challenges of growing a small city the size of Bend within a six-month period were substantial.

The Army quickly approved the funds for the new training center. Only three days after the public announcement, the US War Department advised Oregon senators Charles L. McNary and Rufus C. Holman that the funding for the construction of the camp had been approved. Without specifying the exact cost, the contract was worth about $4 million, and the completion date was set for May 1, 1943.

The editorial page of *The Bend Bulletin* rallied local support for the installation. According to the writer, the first responsibility of Bend's citizens was to show hospitality. It was also a call to show arriving military personnel and construction supervisors "the spirit of Bend."

Judging from the US War Department's basic outline, the ERTC was only a temporary project from the beginning. The Army installation would involve only minimum facilities when it came to shelter, supply, operations, and recreation.

The ERTC was built in the middle of a high desert ponderosa pine forest with little infrastructure. Everything had to be constructed from the ground up, including buildings for 10,000 military personnel and 500 civilian employees. Roads, water, sewers, and electricity had to be built from scratch. In early December, the Army announced the contract for the construction of the unnamed camp had been awarded to Smith, Wright & Hoffman, a joint venture between three Portland, Oregon, firms. The firm was the lowest bidder in the competition for the contract.

The contract to build a spur line from the Great Northern Railroad into the ERTC and the construction of several large warehouses was awarded to Natt McDougall Company, also from Portland. The contract also included clearing, grading, and paving of the road leading from The Dalles–California Highway into the camp. Eventually, the company was also awarded the contract to build the infrastructure of the camp, including sewage, water, and electric lights.

With ongoing military projects in Redmond and Madras, the Army was in need of a local office to provide oversight for the construction projects. The day the ERTC project went public, the Army opened the Bend Area Office of the Portland Engineer District under the leadership of area engineer Lt. Col. Alfred D. Harvey. Maj. Merle E. Wilson was put in charge of the construction of the training center.

The influx of Army personnel resulted in a housing shortage in Bend. The Army Corps of Engineers officials discussed remedies for the situation with Bend city officials as well as Bend Chamber of Commerce executives. One result was construction of military housing, now known as the Officers' Quarters, on the corner of Northwest Portland Avenue and Northwest Fifth Street. Although the ERTC was intended to be self-sufficient, many of the administrative functions assigned to married officers required their presence and thus housing in Bend. These included administrative and supervisory staff personnel who dealt with local contractors and other providers of goods and services.

The name Camp Abbot was approved by officials in Washington, DC, in early December 1942, in honor of the late Brig. Gen. Henry Larcom Abbot, an 1854 West Point graduate and a distinguished member of the Army Corps of Engineers. As a young lieutenant, Abbot was a leader of a Pacific Railroad Survey party that camped by the Deschutes River within the boundaries of the future ERTC on September 2, 1855. Robert W. Sawyer, publisher of *The Bend Bulletin*, who also acted as the chairman of the Bend Chamber of Commerce Military Committee, suggested the name. Sawyer, a history buff, wrote in an editorial that Abbot's name held significance beyond the pick of a campsite by a railroad survey crew.

One

BUILDING CAMP ABBOT

Construction of Camp Abbot officially got underway on December 14, 1942, with three main projects on the list. The first part of the multipronged project was the campsite. The Army had already started constructing barracks that were made available to workers who wished to live at Camp Abbot during the construction phase.

Lt. Col. Alfred D. Harvey led the Camp Abbot construction detail. The 500-person construction detachment comprised both civilian contractors and government employees. The construction of workforce housing started in early November and was finished in the middle of December. A large amount of the living quarters and other buildings were secured from recent Depression-era Civilian Conservation Corps (CCC) camps around the area. The structures were dismantled and moved to the construction site.

The winter of 1942–1943 brought weather many of the construction crews would rather forget. It was the worst winter Central Oregon had experienced in 30 years. Winter came hard to Central Oregon on January 20. Deep snow and freezing temperatures paralyzed Bend and surrounding areas. There was hardly enough time to dig out from the storm before the second storm of the season moved in only 10 days later. The snow conditions at Camp Abbot were even more precarious than in Bend. The contractors reported it was "all hands on deck" to dig out with the hope of starting up work after the weekend. Construction crews first had to remove the snow before grading and utility work could continue. From December 1942 through March 1943, Central Oregon received in excess of 60 inches of snow. Considering the expedited timeline, it was an amazing achievement that the camp stood ready only five months from the start of the project. Camp Abbot became operational on May 1, 1943, as specified by the contract. The same day, a contingent of 250 soldiers arrived in Bend.

Camp Abbot was named in honor of the late Brig. Gen. Henry Larcom Abbot, US Army Corps of Engineers. As a young Corps of Topographical Engineers lieutenant, Abbot was a member of a Pacific Railroad Survey party that camped by the Deschutes River on September 2, 1855, approximately within the boundaries of the training facility named for him 87 years later. (Courtesy of DHM.)

Col. Frank Schaffer Besson, US Army Corps of Engineers, took command of the ERTC on Sunday, May 9, 1943. *The Bend Bulletin's* front-page article briefly described his career. A 1909 West Point graduate, Besson was in command of the 1st Engineers, 1st Division, in World War I. After the war, Besson was stationed at Fort Leavenworth, Kansas, as an instructor at the command and general staff school. (Courtesy of DHM.)

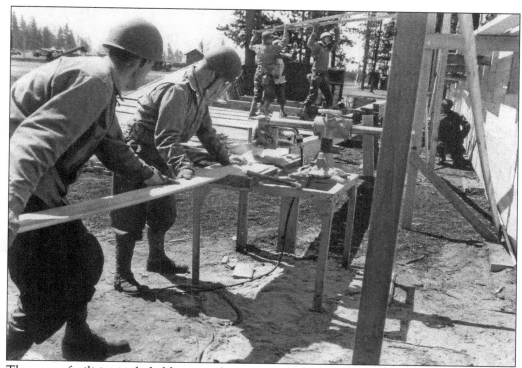

The camp facilities included housing for 10,000 troops in over 50 barracks, administration buildings, office space for civilian employees, mess halls, recreation facilities, several dayrooms, laundry facilities, chapels, storage units, and a hospital with 400 beds. The surrounding Camp Abbot Military Reservation included additional training facilities, like a tactical training area, an obstacle course, a rifle range, a night training course, and a demolition area.

Many of the military construction personnel at Camp Abbot were selected from the Corps of Engineers. The engineers were tasked with building a small city in five months from scratch. Aside from using modern power tools, the engineers also relied on tools going back to the Stone Age. This soldier is smoothing the side of a log with an adze.

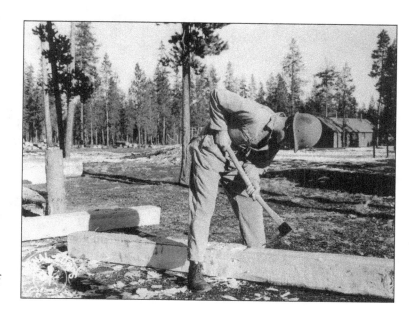

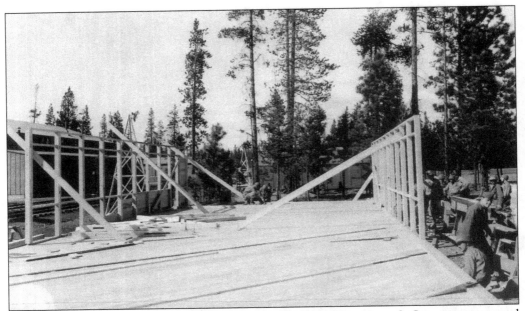

As construction work continued at Camp Abbot, Secretary of War Henry L. Stimson announced on March 25, 1943, that the official opening of the ERTC would take place on May 1. In addition to Stimson's announcement, *The Bend Bulletin* revealed that the newly commissioned camp was going to be run by staff moved from Fort Leonard Wood, Missouri.

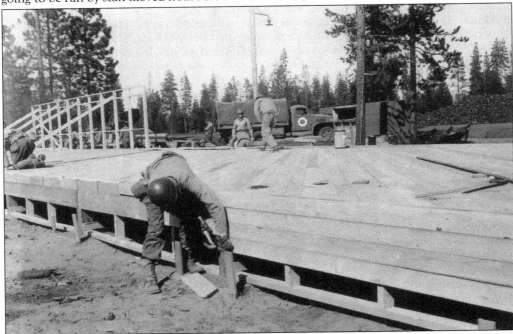

Camp Abbot was energized on April 25, when Pacific Power & Light threw the switch on the brand-new 22,000-volt power line. The construction of the 16-mile line started in mid-December, but work was slowed by the heavy snowfall in January. The new feeder line was completed with great difficulty as the remaining snowpack slowed down work.

The "city" of Camp Abbot grew at a frantic pace in the last months before the project was due to be handed over to the Corps of Engineers on May 1, 1943. What had taken the city of Bend over 35 years to accomplish was done in five months. The project continued into late April with many buildings still under construction.

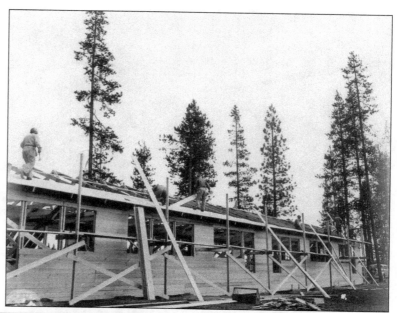

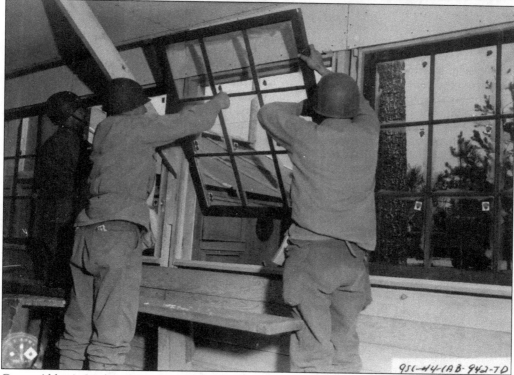

Camp Abbot's 34 dayrooms were sponsored by several local service organizations in Bend. In mid-June, *The Bend Bulletin* published a supply list of material needed for the dayrooms with the hope the community would rally. On the list was 99 floor lamps, 50 bookcases, 71 end tables, 158 straight-back chairs, 130 overstuffed chairs, 100 smoking stands, 180 ashtrays, 67 rugs, and drapes for 720 windows.

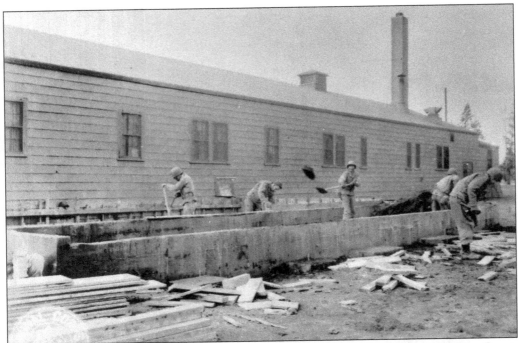

The almost finished Camp Abbot drew interest from military brass from all over the West Coast. The highest-ranking officer to arrive in Bend before the official opening was Brig. Gen. Warren T. Hannum, Pacific Division engineer of the US Army Corps of Engineers. Feted by the Bend Chamber of Commerce, Hannum paid tribute to the work of the engineers called into service. He also noted the accomplishments of the contractors who were building military cities at a speed few could imagine only years prior. He also prepared Bend for what lay in wait as a military city. "The officers will not only be officers, but true to Army tradition, will be gentlemen. There may be some infractions of rules by enlisted men in isolated cases, but officers at camp will take care of these cases." (Below, courtesy of DHM.)

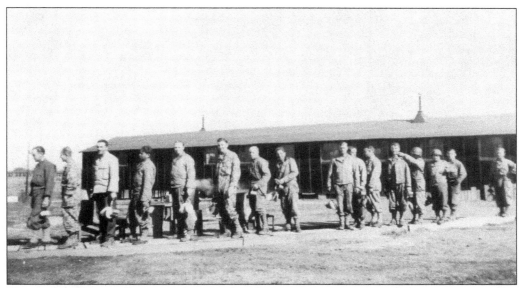

The camp and its staff were ready to go, but the most important part of the training program was still lacking—soldiers. New arrivals kept trickling in. Fourteen soldiers arrived on May 24, mainly from the West Coast. Lt. Col. Coke Mathews assigned the new arrivals to the 51st Battalion, still waiting for another several hundred soldiers before the training program could begin. (Courtesy of DHM.)

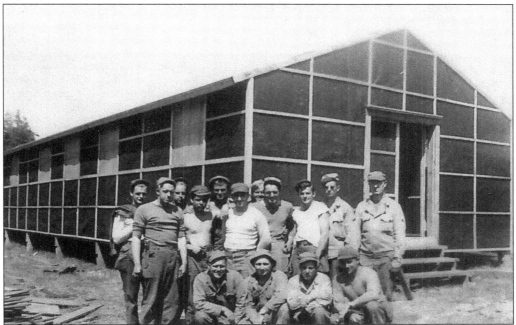

It was clear not everything was in place by the May 1 deadline. With shower facilities under construction, the newspaper reported that 300 soldiers from Camp Abbot would have their first hot shower in two weeks after an arrangement was made between the post and Bend High School. Lt. Paul O'Brien asked Bend's school board if they could use the high school's gym. The school board agreed.

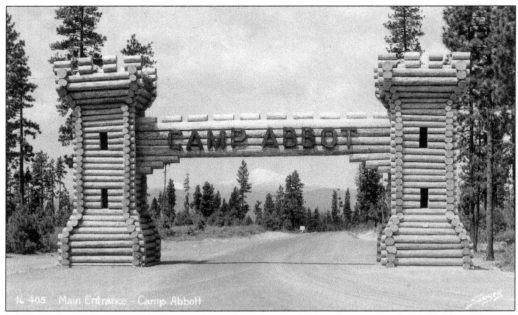

The US Army Corps of Engineers has a long history. The Continental Congress appointed Col. Richard Gridley its first chief engineer in June 1775. Its first engineers were French officers seconded by King Louis XVI to Gen. George Washington during the Revolutionary War. The Corps' castle insignia, reflected in Camp Abbot's entrance, derives from one of the gates of the city of Verdun, France. (Courtesy of DHM.)

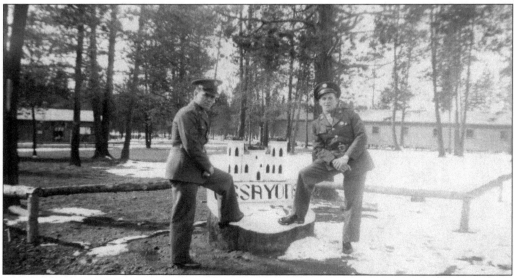

Today's US Army Corps of Engineers was established in March 1802 by an act of Congress. Aside from military duties, the new organization was tasked with nonmilitary projects, such as "civil works" and "rivers and harbors." The official motto comes from those French officers' phrase, "Essayons," or, "Let us try." Camp Abbot featured a small model of Verdun's turreted castle with the motto emblazed on it. (Courtesy of DHM.)

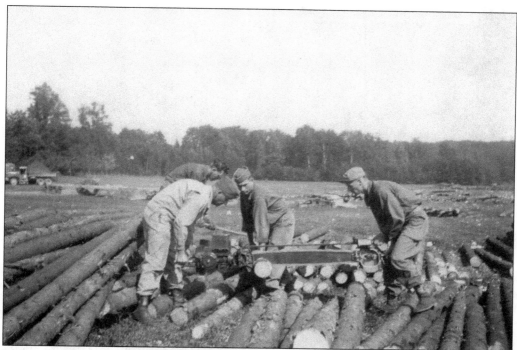

The Army operated its own sawmill and lumberyard at Camp Abbot. This mill was about the size of a mill serving a medium-sized city. Maj. Frederick Landenberger was in charge of this as well as other supply and service functions. Logs were cut to length and sawn into dimensional lumber used in ERTC construction projects. (Right, courtesy of DHM.)

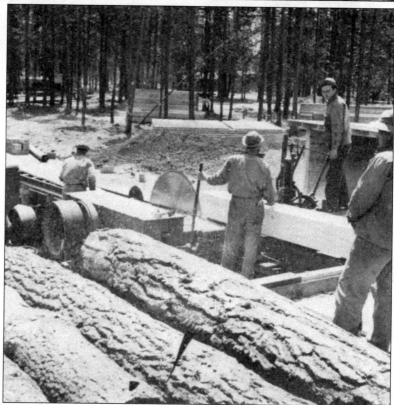

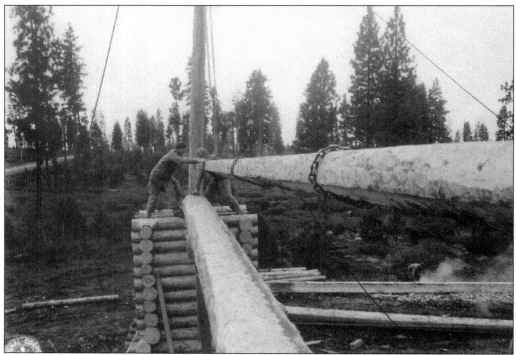

The construction of the entrance gate became a top priority as ERTC set down roots in the high desert. The engineers took pride in building a top-notch replica of the Army Corps of Engineers' insignia. The large hand-hewn logs were carefully put in place, showcasing the skills of the craftsmen who worked on the project. In order to keep the entrance gate from sinking into the volcanic pumice, the engineers poured large concrete footings before starting construction.

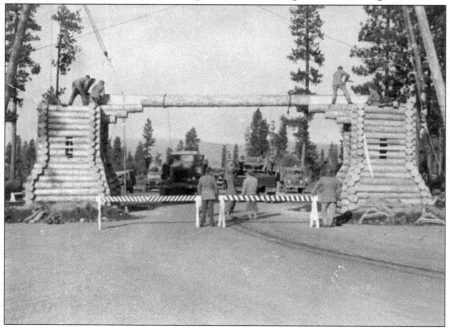

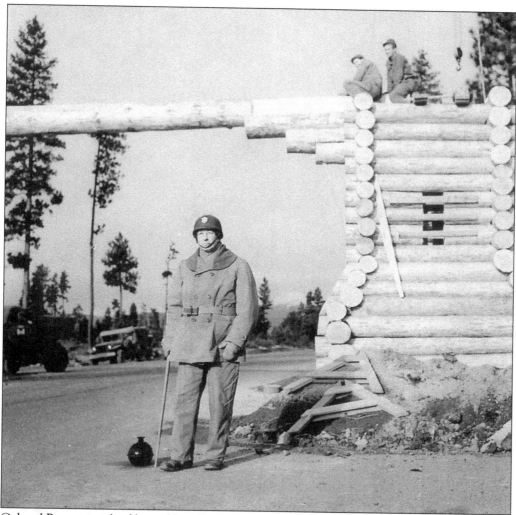

Colonel Besson involved himself in all aspects of Camp Abbot. He closely watched construction of its imposing entrance on The Dalles–California Highway. He was also involved in affairs beyond the Camp Abbot Military Reservation. Concerned about that highway and highway safety threatened by different speed limits for civilian and military vehicles, he enlisted the assistance of Deschutes County district attorney Irving Brown in petitioning Oregon's highway department to lower the speed limit for civilian drivers from 55 miles per hour to 35 miles per hour, which was the limit imposed on military vehicles. Two weeks after Besson and Brown's request, the speed limit was reduced to 35 miles per hour for all drivers. This improved highway safety and solved jurisdiction issues.

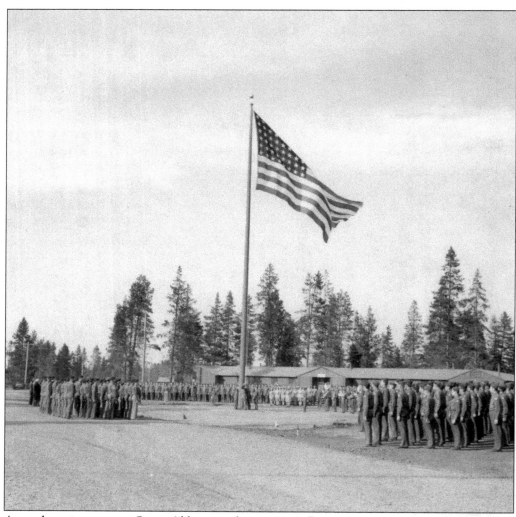

An early major event at Camp Abbot was the garrison's flag-raising ceremony on May 18, 1943, celebrated with all the pomp and circumstance the Army could muster. The public was invited, along with representatives from the City of Bend and its chamber of commerce. Under the baton of Warrant Officer Charles J. Spalding, the 22-piece Engineer Replacement Training Center band played as the troops formed up on the parade field. Shortly before the ceremony, the band struck up the national anthem. A brisk northerly wind swept over Headquarters Square as the 38-foot by 20-foot garrison flag was raised to the top of the 102-foot flagpole. The troops, including two detachments of the Women Army Auxiliary Corps (WAAC), stood at attention as the flag was raised. Speaking briefly, Colonel Besson mentioned that the formal dedication of the camp would happen on either August 12, the 112th anniversary of Brig. Gen. Henry Larcom Abbot's birth, or on September 2, to celebrate the fording of the Deschutes River by the Pacific Railroad Survey engineers on the same day in 1855. (Courtesy of DHM.)

Two

BASIC TRAINING

Training at Camp Abbot, as well as at the other two engineer replacement training centers, was based on hard-learned lessons from combat situations in the European and Pacific theaters of war.

Taking cues from the ERTCs at Fort Belvoir and Fort Leonard Wood, the men at Camp Abbot were not subjected to monotonous activities that went on for hours on end. Instead, trainees moved from course to course to keep the men active and alert. Then, each Saturday, the men were put through tests to assess how well they grasped the lessons learned the previous week.

The training command did its best to expose the soldiers in its charge to any situation they might encounter on the battlefield. In mid-July 1943, Camp Abbot received six obsolete light tanks and one medium tank used to train soldiers how to deal with enemy tanks. In order to teach the troops proper employment of cover, the tanks drove over foxholes and similar entrenchments occupied by trainees. The medium tank was used to test tank traps and other obstacles built by the soldiers, while the light tanks were used to test minefields and fixed and floating bridges they constructed.

Combat engineers at Camp Abbot were also taught Ranger tactics. According to Lt. Clarence Douglas, director of training, the engineer soldiers were often the first troops to breach the beaches and face the initial response from the enemy.

On September 14, 1943, a new training cycle was introduced at Camp Abbot. The previous 17-week schedule was increased to 19 weeks. The revised training schedule was based on lessons learned during the North African and Sicilian campaigns. One of the added features of the new training program was night patrol problems, which included both the right and wrong methods of night tactics.

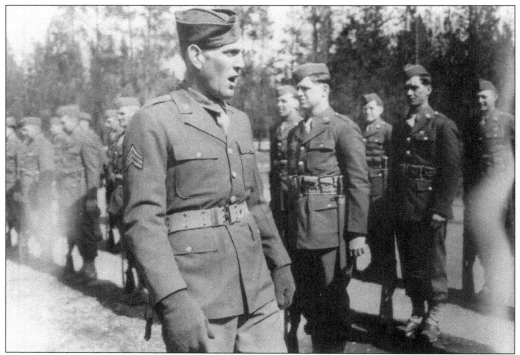

Basic training turned civilians into soldiers. That was the job of the drill sergeant, who became a soldier's best and worst friend during basic training. This introduction to military life included such subjects as how to wear the uniform and display military courtesy.

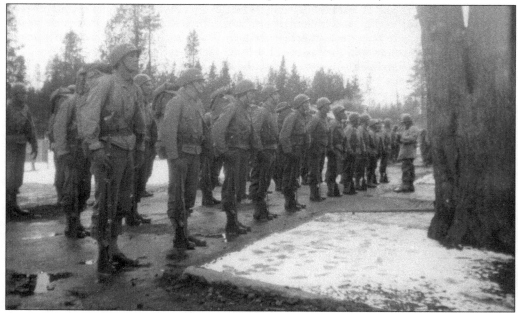

Camp Abbot trainees were issued three uniforms: cotton, wool, and fatigue. In addition, they were issued wool olive drab shirts and overcoats, a field jacket, a raincoat, leggings, overshoes, a knitted wool cap, wool gloves, and helmet liners. (Courtesy of DHM.)

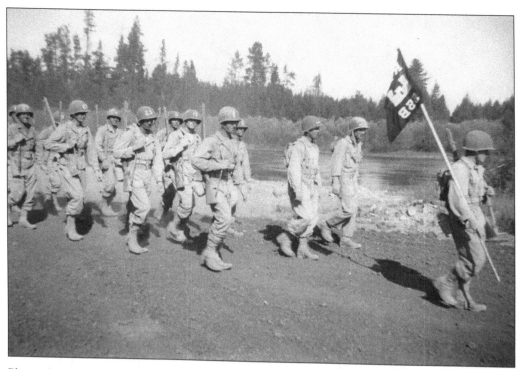

Physical conditioning also started immediately. Trainees were sent on long marches throughout the rugged high desert terrain. Depending on the season, the soldiers had to deal with dust, mud, or snow. The long, dry summer months made day marches a challenge. The red dust penetrated everything and made breathing a challenge, especially for those at the rear of the column.

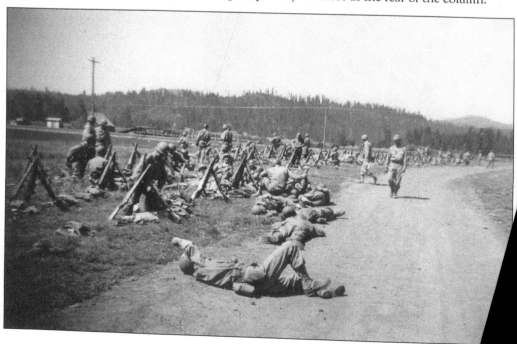

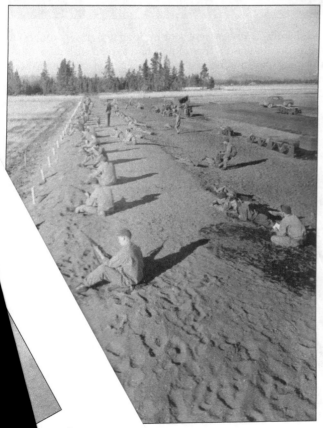

The rifle range at Camp Abbot was located in front of the headquarters buildings. The firing range was put in use on May 30. Four days before, the local newspaper related an order from Colonel Besson, saying May 29 would be the last day for ranchers to remove livestock from the Camp Abbot reservation. The following day, the rifle and machine gun ranges would be in use. (Courtesy of DHM.)

New arrivals were immediately trained how to handle their weapons. Hours upon hours of "dry fire" practice with empty rifles soon turned into live ammunition drills on the rifle range. One commander attested to the fact that the men quickly learned to use their rifles, with 90 percent scoring qualifying marks on their first day on the range. Rifle training continued throughout the soldiers' basic training schedule. (Courtesy of DHM.)

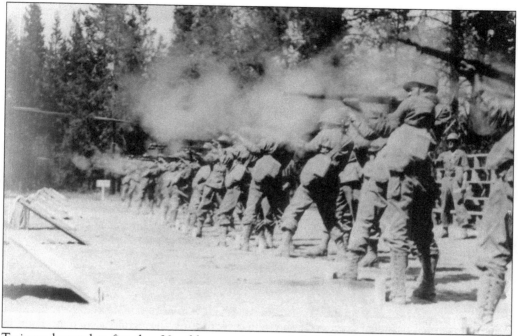

Trainees learned to fire the .30 caliber, semiautomatic M1 Garand rifle. The development of that rifle began in the late 1910s. After several dead-end efforts, the French-Canadian inventor John Garand submitted a winning design, which replaced the 1903 Springfield rifle. Each clip contained eight rounds of ammunition. Once the eight rounds had been fired, the ammunition clip was ejected with a loud "ping" that indicated it was time to insert the next clip. The M1 Garand became the standard-issue rifle during World War II and was considered a reliable and accurate weapon by the troops. Basic training also included the use of machine guns. Camp Abbot had separate firing ranges for rifle and machine gun training. The soldiers below are using the belt-fed, water-cooled M1917 Browning machine gun. (Below, courtesy of DHM.)

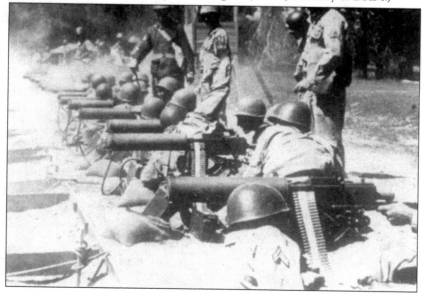

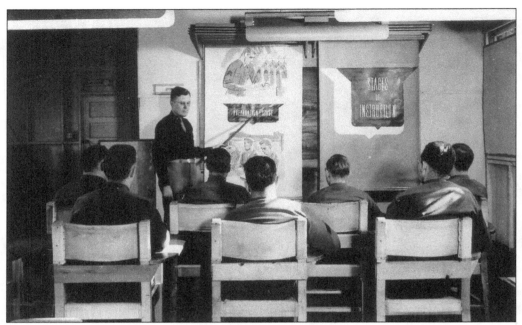

Aside from normal classroom experiences shown in these pictures, the recruits spent many hours in front of a movie screen to view training films that arrived daily from the command headquarters. The Army utilized a huge library of training films to teach soldiers about everything from how to successfully perform raids and strafing missions to avoiding booby traps. An integral part of training modern soldiers, the instructional movies were transferring know-how to the new recruits in the most efficient way. The Army estimated that the reliance on instructional films cut the average training period by 40 percent. The knowledge transfer from the instructional films, followed up by training on the rifle range, and the hand grenade and bayonet course, made sense for each class of replacement engineers.

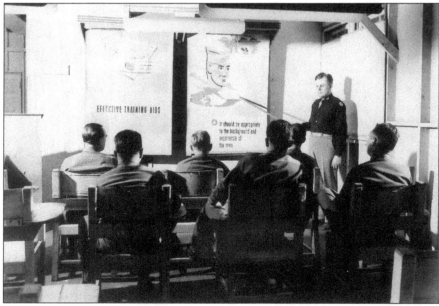

Although The Hague Declaration of 1899 and The Hague Convention had outlawed chemical warfare in 1907, both French and German forces used chlorine, phosgene, and mustard gas on World War I battlefields. In preparation for fighting in Europe and the Pacific, Camp Abbot trainees received extensive instruction on detecting and protecting themselves against gas attacks.

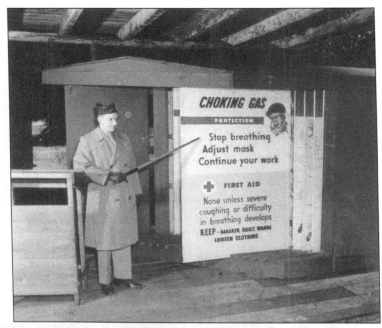

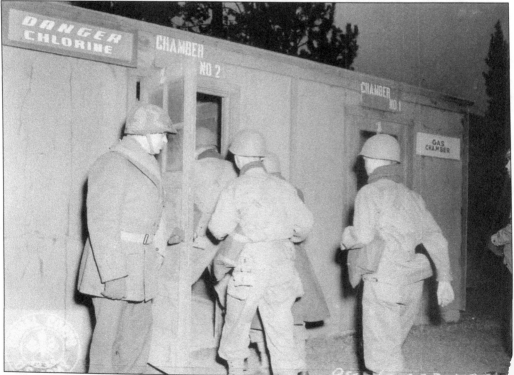

This included one of the less appreciated activities during basic training, a trip to the "gas chamber." With a gas mask in hand, the soldiers were sent into the hermetically sealed room. Once inside the training staff filled the room with choking gas while the recruits quickly donned their mas Most of the recruits stumbled out of the chamber coughing and gagging.

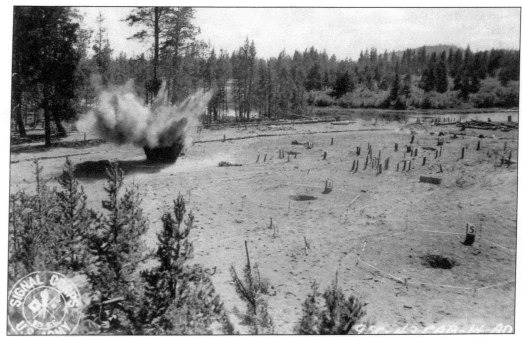

Camp Abbot's training obstacle course was called "The toughest course in the United States" by the training officers at the camp. As part of basic training, the soldiers were sent out on the 435-yard course in any type of weather, in full view of the post commander's quarters. Built to increase the stamina of the trainees, the track included 16 obstacles. The soldiers started off scaling an eight-foot wall, rapidly followed by attacking over breastworks, making a six-foot jump, and charging over a wall of pine logs. One of the post's spokesmen, Sgt. George S. Fly, asserted that the course was tougher than charging through a mock German village "filled with booby traps and land mines." Colonel Besson liked the obstacle course and completed it on several occasions.

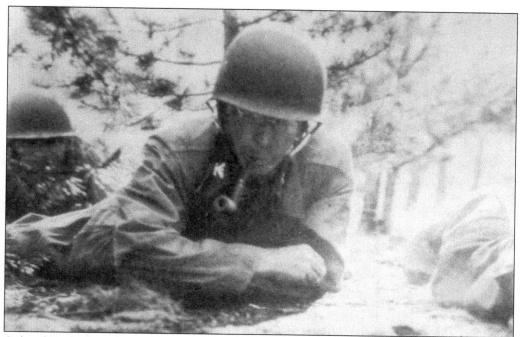

Colonel Besson was not afraid to show his prowess in negotiating the same infiltration course. During a training session with the camp's high-ranking officers in early August 1943, Maj. LeCompte Joslin, director of weapons training, saw his commanding officer in action. Arriving at the course, Besson and Harold French, assistant field director of the American Red Cross, were ready to go. With his pipe firmly planted in his mouth and dressed in battle uniform, Besson joined the second wave. After going "over the top," the colonel demonstrated his ability to low-crawl the barbed wire entanglements with relative ease while live ammunition streamed 40 inches above his head. Besson and the rest of the officers in his wave made it to safety on the other side of the course without a scratch.

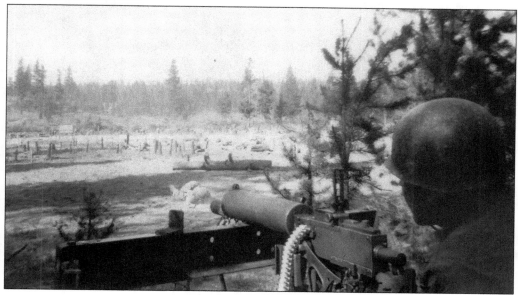

An important part of the training regimen at Camp Abbot was to practice defense against enemy airplanes. The director of the training division, Col. Clarence J. Douglas, devised a training program for the soldiers stationed at the camp. As US Army flight students were flying normal sorties during their training, they would fly "missions" over Camp Abbot and "bomb" and "strafe" the engineer troops. They, in turn, would take cover and simulate firing at the "enemy planes." The Army had several air bases throughout Central Oregon. The Army air base in Redmond was part of the Second Air Force, while the Army airfield in Madras was part of the Air Technical Service Command. Madras Air Base was home to B-17 Flying Fortresses and Bell P-63 Kingcobras while Redmond's Roberts Field was the base for P-38 Lightnings. Redmond Air Base is pictured below. (Both, courtesy of DHM.)

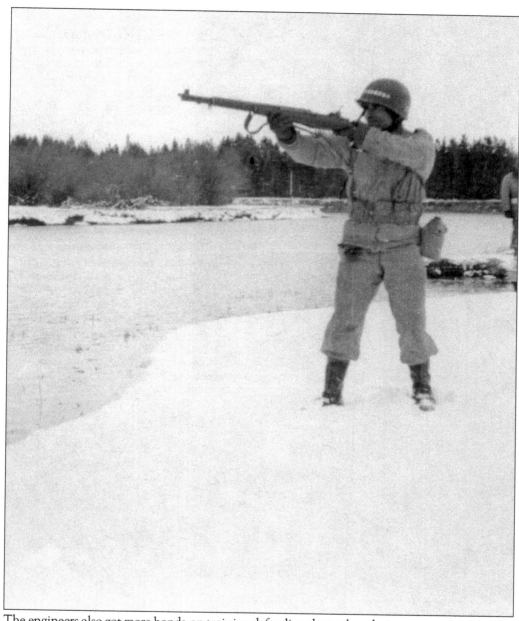

The engineers also got more hands-on training defending themselves during enemy air raids. The rifle range was equipped with a shooting gallery to simulate enemy airplanes. The targets were attached to a trolley system that simulated an airplane at any angle of attack: climbing, diving, approaching, retreating, and level flying. Each target simulated eight planes, oblong figures about two inches wide and less than a foot long. To get the soldiers to fire ahead of the fast-moving target, each airplane had an identical shape ahead to teach the soldiers to aim ahead in order to hit the target. The men were arranged in groups of eight for each firing order, each soldier assigned one of the eight targets. The firing line was only about 100 feet from the targets. Instead of the more powerful M-1 Garand utilized by the troops during training, each man was issued a .22 caliber rifle. (Courtesy of DHM.)

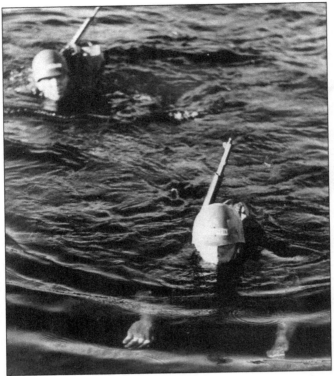

One of the courses at the camp was swim classes. In the process of adding millions of men, the armed forces realized that only 10 percent were proficient swimmers. The remaining 90 percent were either not able to swim or were considered novice swimmers. To rectify the issue at Camp Abbot, the Red Cross started training swim instructors at the pool at Bend's high school gym. The original 50-hour course was condensed to 30 hours and included classes on how to leap from a sinking ship, swim under burning oil, disrobe in the water, and swim with full field equipment. Fred Amick, a Red Cross field representative, taught the classes. Once the swim instructors were licensed, they in turn taught the trainees the same course.

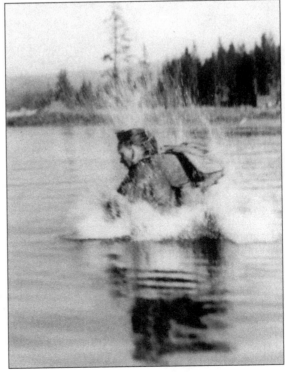

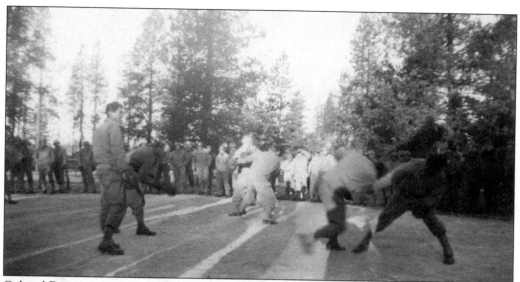

Colonel Besson was a proponent of teaching soldiers how to defend themselves in close-quarter situations. One of his favorite exercises was the free-for-all boxing events every new trainee had to experience. Equipped with boxing gloves, a group of soldiers pummeled each other inside a large marked area. The boxing events were a part of the athletic program and also an activity when dignitaries visited Camp Abbot. (Above, courtesy of DHM.)

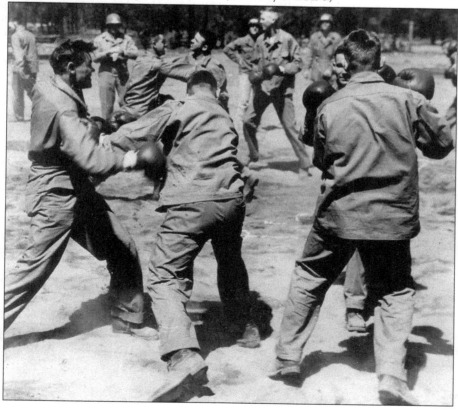

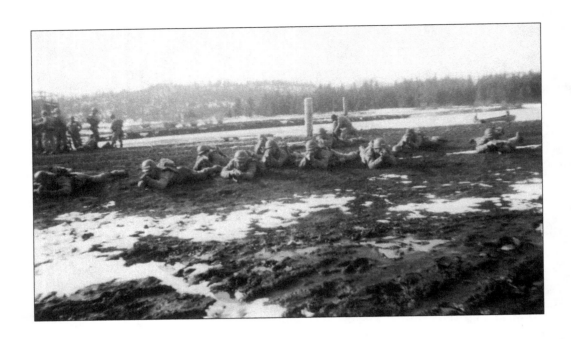

Good morale was important to the welfare of Camp Abbot trainees, as Maj. Russell Turrill, chief of the personnel section, discussed with Lieutenant O'Brien, public relations officer, on a broadcast on local radio station KBND. "Without morale, a unit cannot go far in battle, and one of our purposes here at Camp Abbot is to instill in every soldier a fighting heart and the will to become superior to any opponent he may meet in battle. With cooperation among those responsible for an enlisted man's training, and with a fixed goal in view, every soldier to leave Camp Abbot will know full well he has the stuff to overcome his foe." (Both, courtesy of DHM.)

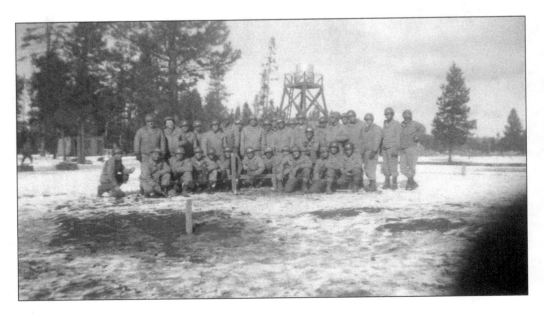

Colonel Besson drove home this concise message to soldiers at Camp Abbot: "Sweat Saves Blood." Over 900 replacement engineers completed their training every two weeks. Each soldier going through the program was eventually sent to the battlefield to replace a wounded or killed combat engineer. The course was often the only training a soldier received before shipping out. "For that reason, training here must be perfect," said Colonel Besson. He had nothing but high hopes for Camp Abbot, saying he wanted to command the finest ERTC in the United States. (Above, courtesy of DHM.)

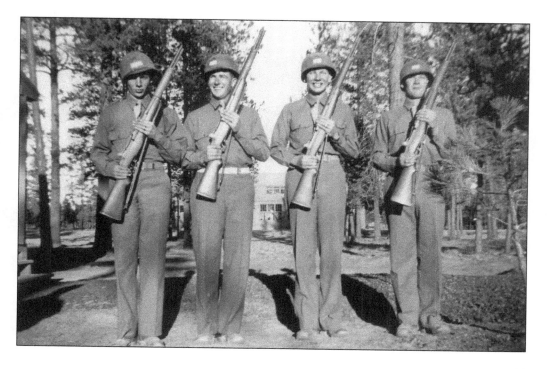

After a few short weeks of intense training at Camp Abbot, civilians from all walks of life had become soldiers. With a wide range of experiences, auto mechanics, lumberjacks, bank tellers, farm boys, stockbrokers, sports writers, or any imaginable job description flocked to recruiting stations all over the United States. Raised in small towns or big cities, joining the Army turned their lives upside-down. Boarding trains or buses, they were sent far away from the familiar surroundings of their hometowns and bunched up with complete strangers in unfamiliar surroundings. Joe from New Jersey met Tom from Wisconsin, who in turn met John from Texas. Their first shared experiences built a special camaraderie, which made them a part of Camp Abbot forever. Now they were ready for their next big challenge, specialist training. (Above, courtesy of DHM.)

Three

SPECIALIST TRAINING

After completing basic training, Camp Abbot trainees were evaluated for and assigned to specialist training based on interviews and tests conducted on arrival as well as performance during basic training.

Based on their performance in basic training and their aptitudes, soldiers were assigned to training companies to become cooks, carpenters, automotive mechanics, tractor drivers, heavy-equipment operators, or demolition crewmembers. Men without aptitudes for these specialties received training as basic combat engineers. Soldiers were also evaluated on their abilities to lead. After completing training at Camp Abbot, some were sent to further training or officer candidate schools.

The specialist training at Camp Abbot was tough. The soldiers went through intense training on how to fight, build, and destroy. Although considered engineers, ERTC graduates were as much a part of the fighting force as other soldiers. The combat engineers had to know both how to build and how to fight. The process of building a bridge over a river with enemy soldiers holding one side of the riverbank was fraught with danger. The construction of a bridge sometimes meant the engineers had to take and hold a bridgehead in enemy territory after fording a river under fire.

Combat engineers had to be ready for anything the enemy had to offer. Not only did they have to learn how to build anything from simple rope-tow bridges for troops to cross a small ditch or river to pontoon bridges that could carry tanks and troop transport convoys, the engineers also had to learn to destroy bridges to stop enemy troop movements and build emergency antitank ditches. One of the tougher assignments was to build a bridge in total blackout with only two flashlights for guidance.

Although bridge building at night was a tough challenge, it was not without humor. One story related in the *Abbot Engineer* described a night training maneuver in complete darkness. "Again, and again an officer would be addressed, 'Hey bud, give us a hand here' when the dark made insignia difficult to see. The officers usually obliged."

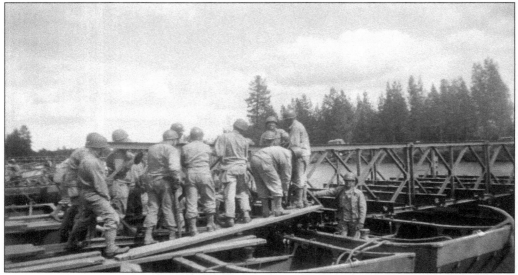

The quick-flowing Deschutes River challenged the men, who had to become adept in the art of building everything from primitive wooden bridges to pontoon bridges. Before the trainees were let loose on building bridges spanning the river, they were taught basic construction principles on dry land. Safety was a top priority. The fact that no trainee perished is a testament to the care the training officers showed. (Courtesy of DHM.)

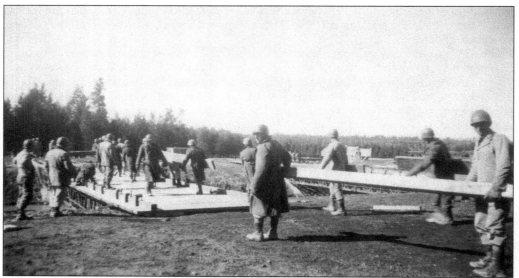

Time proved critical when the engineers arrived in combat zones. Even under heavy fire, the combat engineers would have to work expeditiously because any delays could have dire consequences for planned military operations. The fighting engineers were trained for both offensive and defensive actions while constructing bridges. (Courtesy of DHM.)

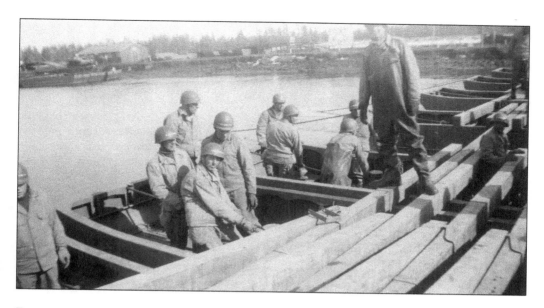

Engineer training effectiveness at Camp Abbot was measured by how quickly trainees could span the Deschutes River with a bridge. In mid-August, a company set a new record when it built a heavy pontoon bridge over the river in four hours, shaving two hours and five minutes from the previous record. Capt. Stuart M. Johnson, company commander, attributed this new record to thoroughly studying the problem the day before the maneuver. Each member of the team knew his job before they reached the construction site. Johnson also acknowledged Maj. Lawrence Fuller's newly devised patrol system as another reason the bridge construction went off without a hitch. The new system divided each squad into three five-man patrols, each with its own patrol leader and specific set of tasks during the construction phase. (Above, courtesy of DHM.)

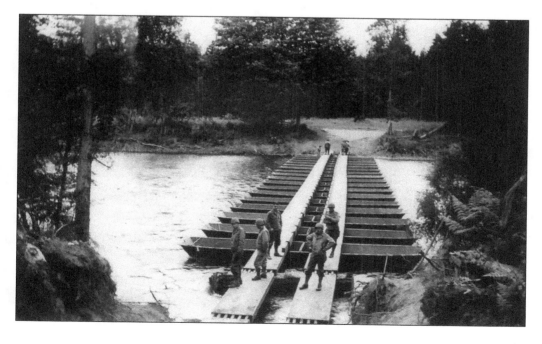

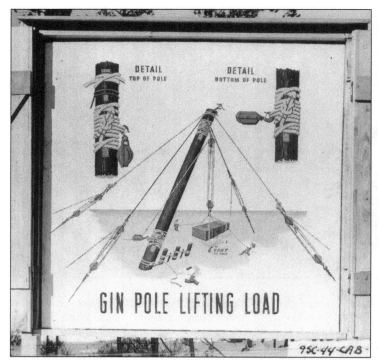

Use of the gin pole was one of the first lessons learned by rookie soldier-engineers. Thanks to rigging, blocks, pulleys, and manpower, the engineers could use this simple contraption to load and unload building materials and heavy equipment. Cranes were seldom available at the front line. Instead, the soldiers were taught to improvise with material readily available. The gin pole was a perfect example of this improvisation.

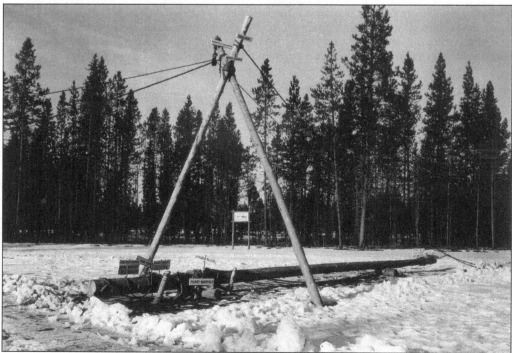

Construction of the gin pole was straightforward. The device used either one or two legs securely fastened to the ground by picket holdfasts. The two-legged gin pole was secured at the top with heavy shear lashing to keep the logs acting as one unit.

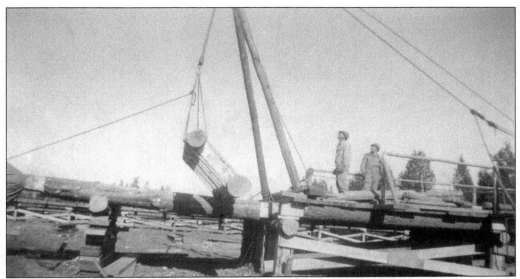

Gin poles were used during construction of trestle bridges to move heavy loads into place. The lifting action resulted from using blocks to winch up the load beneath the leg or legs of the gin pole. Once the load was raised, the pole and the load moved forward or backward with the help of a pulley system. Though simple in design, the gin pole enabled lifting heavy loads in tight quarters. Gin pole use was not without dangers, as pulleys or ropes could snap and send loads flying, injuring or killing soldiers below. The bridge builders in these two pictures are using the gin pole to move large wood assemblies into place during the construction phase of a log bridge. (Both, courtesy of DHM.)

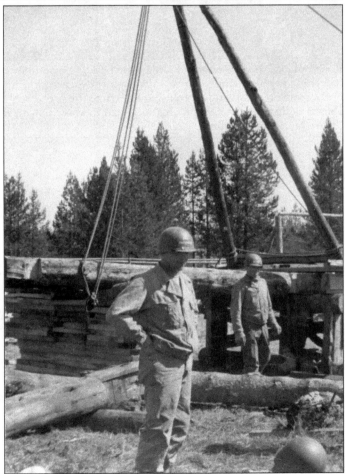

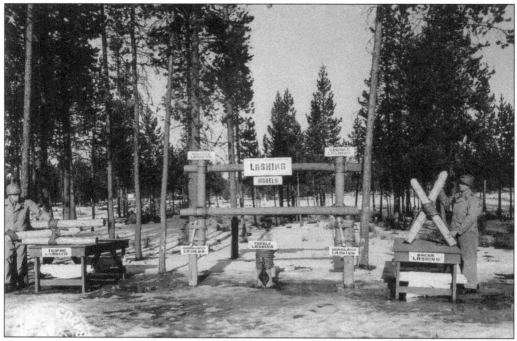

Ropes and knots were essential for lashing building materials together. Trainees learned the art of lashing at this lashing course. Although the Army was highly mechanized, construction of bridges and other structures often came down to the bare essentials. Reminiscent of salty seadogs aboard sailing vessels, combat engineers had to know how to tie mooring hitches, sheet bends, square knots, and bowlines.

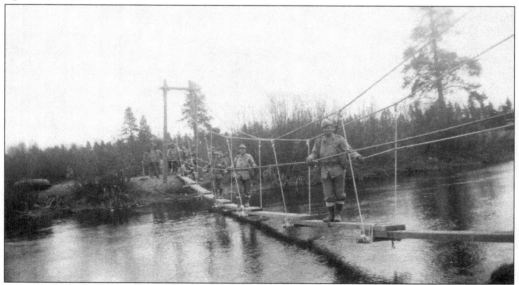

During specialist training, combat engineers became expert riggers who could build bridges that transported men and material across slow-moving creeks or wide, fast-flowing rivers. From simple suspension footbridges to large pontoon bridges that carried heavier loads, ropes, lashings, and knots helped hold it all together. (Courtesy of DHM.)

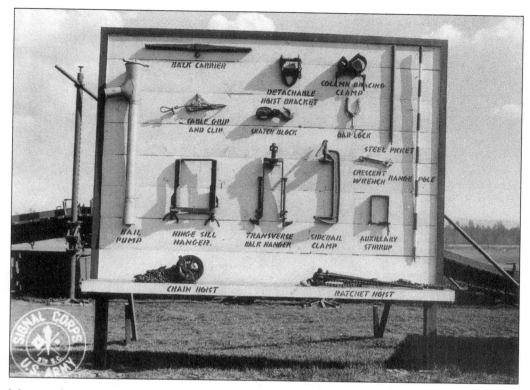

More sophisticated bridges, especially pontoon bridges, relied on more modern engineering techniques. Once the pontoons were in place, combat engineers installed treadways, or road surfaces, that carried foot and vehicular traffic. The instruction board above shows many of the tools needed to attach the wooden or metal decking, or treadway, to either aluminum or rubber pontoons. Below, Camp Abbot trainees secure the wooden treadway with large side-rail clamps. (Below, courtesy of DHM.)

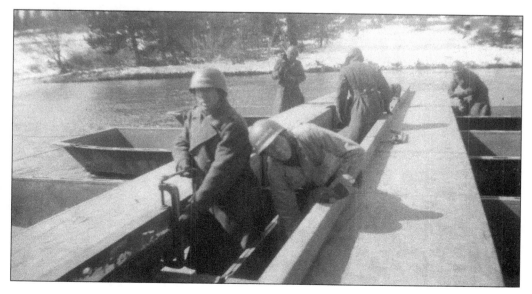

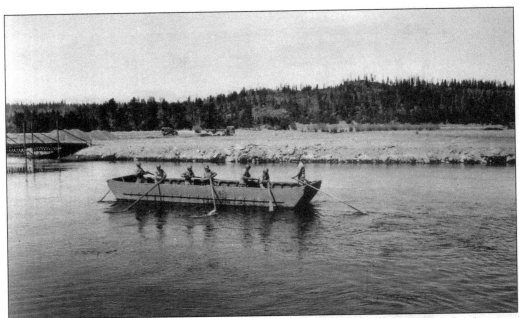

The pontoon bridge developed from the early "bridge of boats" made from wooden boats to specialized equipment made for river crossings. The Army used both scow-like aluminum-alloy half-pontoons and pneumatic rubber pontoons. The engineers at Camp Abbot received training on both types. The larger and heavier aluminum pontoons were not as nimbly maneuvered as the rubber pontoons, but they allowed for the construction of heavier treadway bridges.

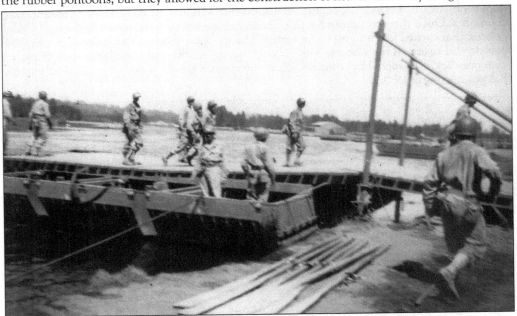

The first part of the bridge-building operation was to secure the abutment area. As the engineers approached a river, they immediately constructed an abutment of heavy timber. The team also drove down the anchor-cable holdfast on both sides of the abutment area. The anchor cable was then transported to the other side of the river and secured.

Once the abutments were securely fastened to the shore and anchor lines were secured across the river, each section of the pontoon bridge was floated into position. As seen here, the trestle balks have already been affixed to the aluminum pontoon. Staggering the balks allowed heavy equipment to cross each section without breaking the bridge.

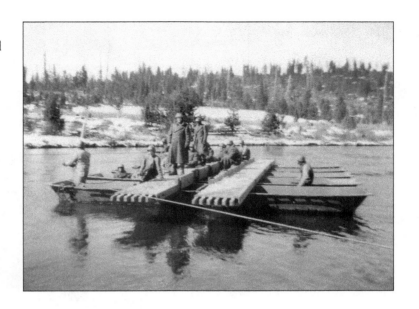

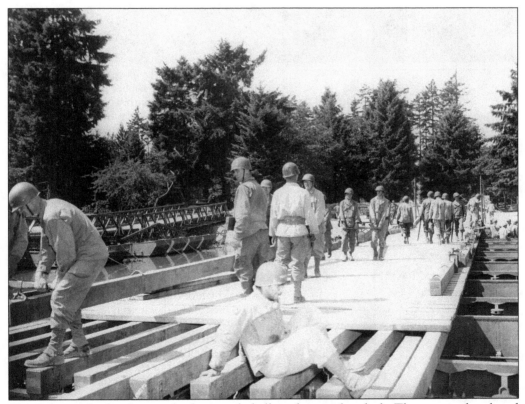

This pontoon bridge features both a trestle balk and a wooden deck. The seemingly relaxed atmosphere seen here would be unthinkable when attempting to build a bridge across a river defended by enemy forces holding the other side. Behind this bridge is a smaller pontoon bridge for troops on foot. (Courtesy of DHM.)

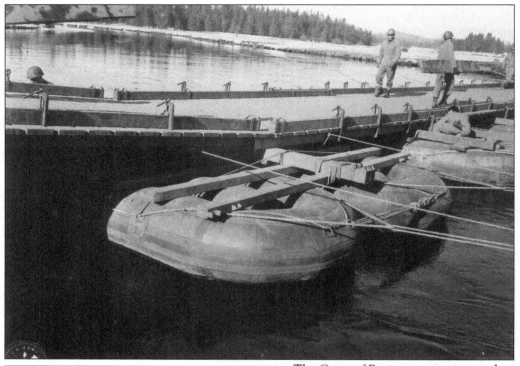

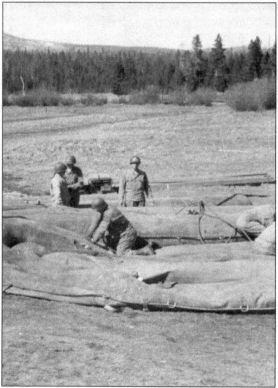

The Corps of Engineers experimented with inflatable rubber pontoons as early as 1834. Trials with wooden pontoons or pontoons made from India rubber bags proved impractical. It was not until the development of cotton-canvas pontoons during the Civil War that the concept of air-filled floating devices was validated. Success came many decades later with the development of suitable rubber.

Much of the bridging material came prepackaged. The rubber pontoons were delivered deflated and rolled up. With the help of a compressor truck, the rubber pontoons were inflated and transported to the bridge assembly. Each 600-pound pontoon took only eight minutes to fill. In preparation for building the bridge, engineers installed either a steel or wood frame and a wooden saddle to distribute the weight of the treadway. (Courtesy of DHM.)

Some bridge components had to be fashioned from on-site material. Combat engineers used chain saws, axes, and the adze for this purpose. The adze was used to remove bark from logs and shape them into timbers. The most important adze-using advice from instructors was: keep hands apart, use short strokes, do not raise the adze higher than your waist, and spread your legs. (Courtesy of DHM.)

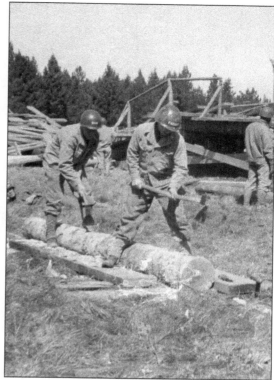

A crew of 11 soldiers could carry each component to the bridge construction site. Once in the water, pontoons were placed in position with the help of pull ropes, paddles, or outboard motors. Pictured here is an assembled section of the pneumatic pontoon with the float transoms and float sills in place.

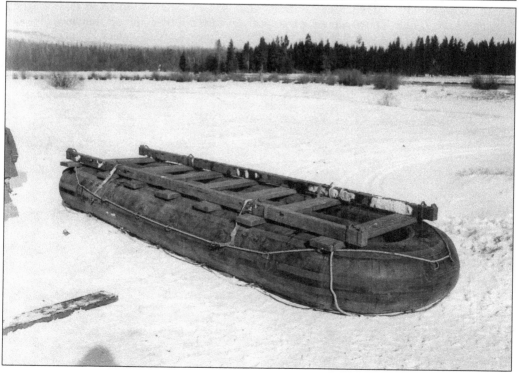

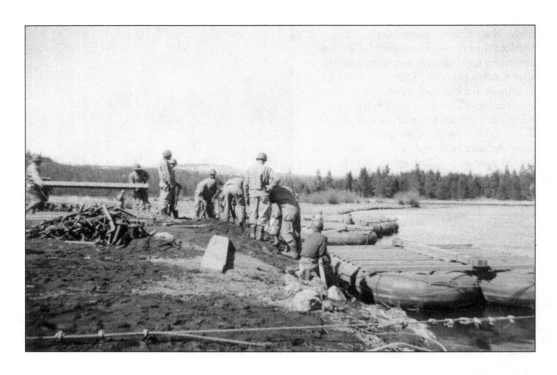

The Army had three basic floating bridges in its arsenal: the M1938 infantry footbridge, M1938 pontoon bridge, and the M1940 treadway bridge. Each was rated depending on its load-bearing capacity. These bridges could bear loads from 10 to 40 tons. The M4 Sherman tank weighed between 38 and 42 tons. The pneumatic pontoon bridge was easier to construct than metal bridges and could be more quickly assembled than the older aluminum pontoon bridges. Rubber pontoons could be fully submerged and still provide buoyancy. Although the rubber was not impervious to enemy fire, each pontoon was constructed with 10 separate compartments to minimize risk of sinking by small arms fire or shrapnel. (Both, courtesy of DHM.)

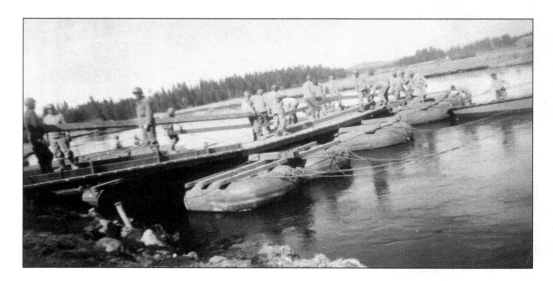

Hanging on to the anchor wire, engineers pull each section of a pontoon bridge into place. Although not as great an obstacle as the large rivers in Europe, the fast-flowing Deschutes River still made for challenging conditions for the budding engineers. Many of the replacement engineers would serve in the European theater of war, where they came up against much wider rivers.

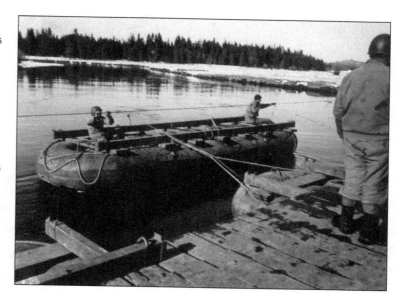

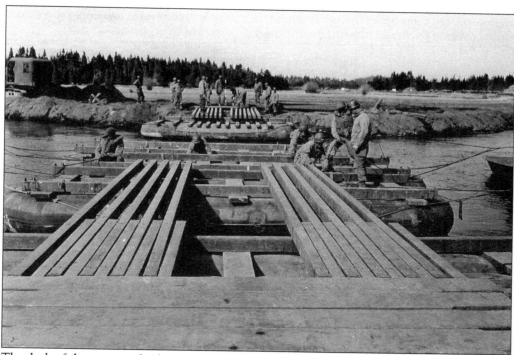

The deck of the pontoon bridge was constructed with either wooden or aluminum trestle balks laid on top of the pneumatic or aluminum pontoons. Depending on the load-bearing requirements of the bridge, the engineers could lay either trestle balks or fir flooring. The trestle balks were laid lengthwise across the pontoons while the fir deck, or "chess," was laid diagonally.

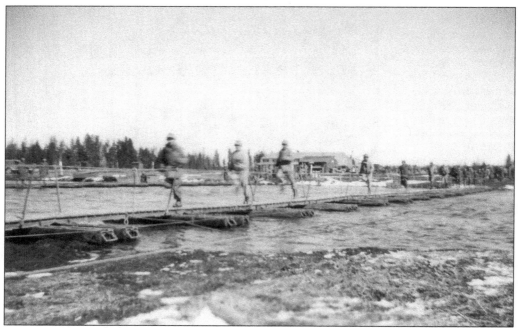

Engineers were tasked not only with building bridges for heavy equipment but also footbridges for infantry soldiers. River crossings were some of the most dangerous operations during the war. Engineers often came under enemy fire during the assembly of the bridge, and once the infantry started crossing the bridge, the firing intensified. (Courtesy of DHM.)

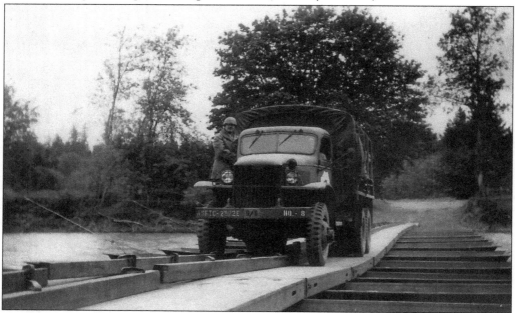

Pontoon bridges moved up and down with their loads. A treadway bridge had separate tracks for vehicle wheels. As this Army "deuce-and-a-half," or 2.5-ton cargo truck, moved across the sections of the bridge, the large side-rail clamps kept the guardrails and substructure in place while allowing the span to move with the vehicle.

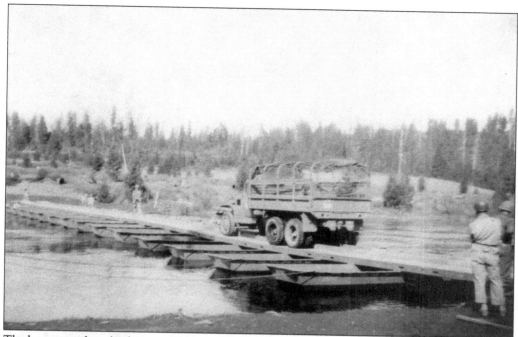

The heavy treadway bridges were built to withstand the force of rapidly moving military equipment. Although the pontoon bridges were rated for certain speeds depending on the construction, during combat it was a life or death decision to cross the river, which made any driver throw caution to the wind. Here, a 2.5-ton cargo truck is crossing the river.

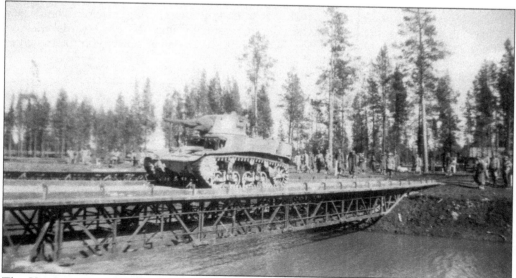

This H-10 treadway bridge laid across the Deschutes River was constructed to carry loads weighing up to 10 tons. One of Camp Abbot's light tanks is crossing the river. Camp Abbot's tanks had been slated for the scrap pile, but thanks to the Army's salvage program, they were used for training purposes. These tanks, built for export to the Chinese, were returned because they failed to meet specifications. (Courtesy of DHM.)

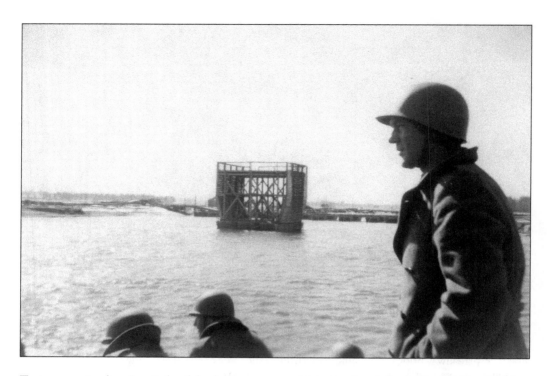

Trainees trained to "run" the debarkation tower, which simulated the hull of a ship. Combat engineers often arrived in combat zones aboard transport ships. They debarked from these ships by Jacob's ladder to landing craft, which delivered them to the beach. Placed in the Deschutes River, this debarkation tower simulated that transition from transport to landing craft. For realism, speedboats were used to make the water choppy around the tower during exercises. The soldiers had to climb the ropes as the tower was heaving and pitching. Camp Abbot had two debarkation towers. In addition to the one in the Deschutes River, the second was placed on the "tough as hell" obstacle course. (Both, courtesy of DHM.)

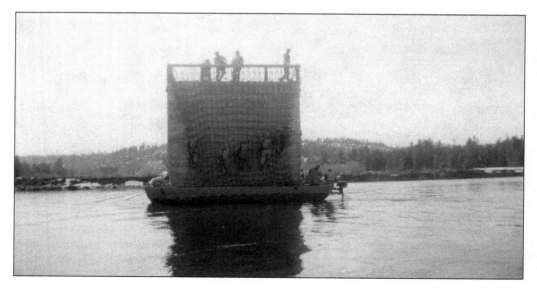

The engineer soldiers had to be comfortable with scaling and climbing the Jacob's ladder. Danger was always close during debarkation. Weather, rain, and fierce winds could make the trip over the side a life or death experience. A lost grip or a slip of the boot could cause a soldier to fall between the ship and the waiting landing craft, with disastrous consequences. (Courtesy of DHM.)

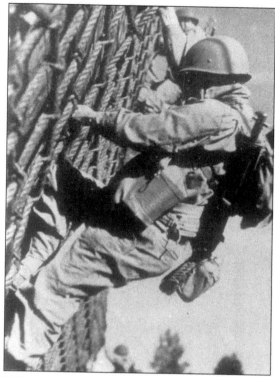

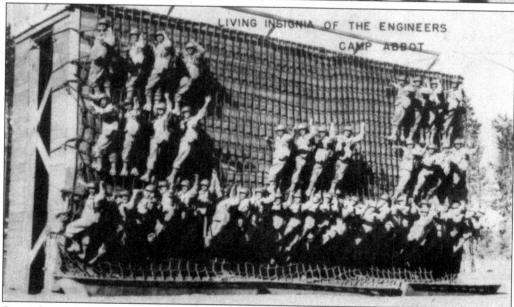

Specialist training at Camp Abbot was tough. Soldiers became proficient engineers on an accelerated training schedule. By the time specialist training was over, the former greenhorns had become skilled bridge builders. Even though the citizen-soldiers were steeped in an intense training schedule, levity was never far away. This postcard photograph shows trainees forming a Corps of Engineers insignia on the land-based debarkation tower.

Neither 0-to-100-degree temperatures nor rain, sleet, or snow stopped the training activities. The Central Oregon winter of 1943–1944 was relatively mild compared with the previous winter, but harsh enough to prepare the soldiers to deal with anything the weather gods threw at them. Many of the engineers wound up fighting in Europe during the bitter cold winter of 1944–1945. (Courtesy of DHM.)

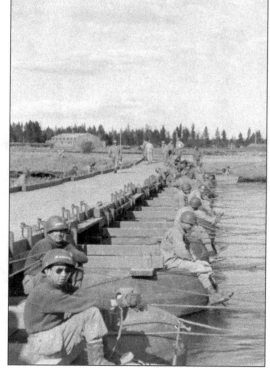

Central Oregon offered up typical high desert weather with cool nights and sunny days. Temperatures during much of the summer ranged from 30 degrees in the morning to over 90 degrees in the afternoon. Uniforms for all weather conditions were issued. Cool temperatures around the river made for a chance to catch sunny-day rays while working on bridge building. (Courtesy of DHM.)

Four

FIELD TRAINING PROBLEM

Combat engineer training at Camp Abbot ended with a three-week "field problem," in which trainees were challenged to put all their hard-earned skills to use. After living in relative comfort during basic and specialist training, this exercise evicted them from their barracks and mess halls for three rugged weeks in the woods.

This field problem gave the engineers a taste of what they would face on the battlefield. The maneuver normally assumed an enemy landing somewhere along the Oregon Coast. After weeks of fighting, the enemy had advanced inland as far as Central Oregon, bombing Bend and destroying important infrastructure such as roads and bridges. It was time for the combat engineers to spring into action and build replacement bridges over which US Army troops could counterattack enemy forces.

In a February 1944 letter to the members of the 52nd Engineer Training Battalion, battalion commander Maj. Lawrence Fuller laid out his unit accomplishments during their final maneuver: "In 12 training days, you have shown how much 14 weeks of training can teach you." Fuller wrote that the rigorous 12-day field problems included building four H-15 bridges and eight footbridges across the Deschutes River, preparing 12 bridges for demolition, marching 15 miles in snow and ice, completing 32 reconnaissance missions and 18 squad combat missions, laying 1.5 miles of road using material sourced from a local cinder pit, and clearing, grading, and laying bar and rod to build a 1,200 by 200 foot airstrip.

Major Fuller's letter also mentioned that the intense training program had taught the engineers to "live, work, and fight close to the ground, with little equipment and no comfort—no beds, cooked meals, nor even fires." In line with Colonel Besson's "Sweat Saves Blood" motto, Major Fuller concluded the letter with, "You now go well trained to meet any kind of tough job."

The day after Christmas 1943, the 51st Engineer Training Battalion began its final phase of the engineer training program. With a foot of snow on the ground, it was time to head out on the three-week field training problem. The battalion moved out under the guise of a bridge-building exercise. The troops were told they were going to assemble a pontoon bridge over the half-frozen Deschutes River. (Courtesy of DHM.)

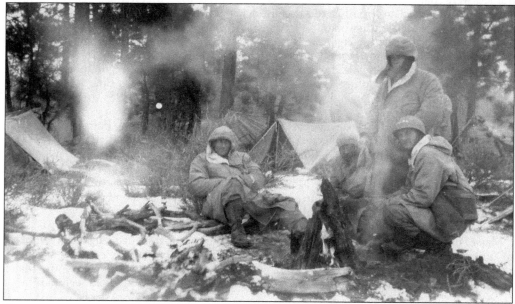

The maneuver area was delineated as a quadrant bounded by Century Drive, the Old Bend-Burns Highway, the Paulina Mountains, and Camp Abbot. While bivouacked on Monday evening, the exercise scenario was rumored to be that enemy planes had bombed Portland and Salem. The following morning, the rumor proved real, and the battalion was ordered to take up defensive positions at Bessie Butte, southeast of Bend. (Courtesy of DHM.)

In an *Abbot Engineer* interview, Maj. LeCompte Joslin stressed that everything from that point would simulate actual combat. As the maneuver progressed, orders were given verbally, and the officers acted as if everything were real. Winter brought on added challenges. The cool dry mountain wind penetrated every article of clothing, making outdoor work a chore. Add wind-driven snow, and life on the high desert became even more miserable.

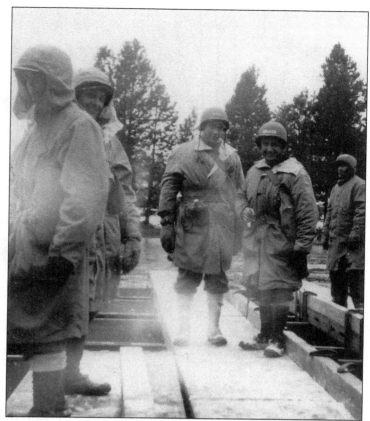

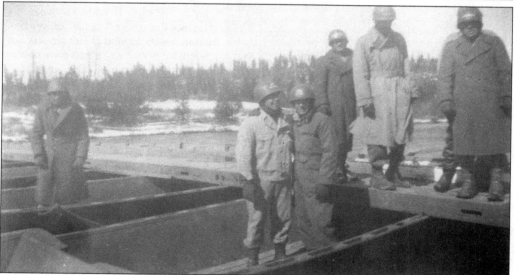

As the mock war progressed, the engineers were ordered to build a road using locally sourced material, maintain reconnaissance patrols in the area, and prepare two river crossings. The only breaks in the war games were two Sundays, when the battalion returned to Camp Abbot to prepare for the next list of problems. (Courtesy of DHM.)

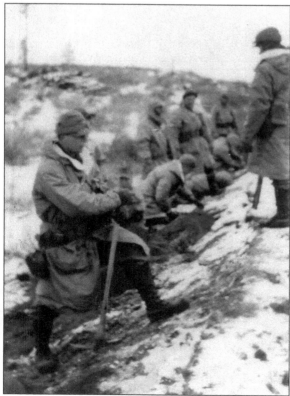

New Year's Eve 1943 fell on a Friday. As Major Joslin had promised, the maneuver continued without a break. This meant the battalion spent New Year's Eve and the following day in foxholes. To add a twist to the mock war, the "enemy" dropped paratroopers around the engineers' defensive positions, which took the out-guards by surprise. The enemy troops inflicted heavy casualties before being defeated. (Courtesy of DHM.)

As the maneuver continued, the troops practiced building defensive positions such as antitank ditches, gun positions, and personnel obstacles. The Central Oregon winter continued to throw all its might at the soldiers in the field. Snow kept falling in the general area of the maneuver. As the soldiers dug in for the evening, the weather deteriorated quickly. They finished digging their foxholes in a blinding snowstorm.

Real live news was never far from the front line, even during field maneuvers. During brief breaks in the action, these soldiers caught up on current events in the *Oregon Journal* about the war they would soon fight. A GI truck was quickly transformed to a makeshift bulletin board.

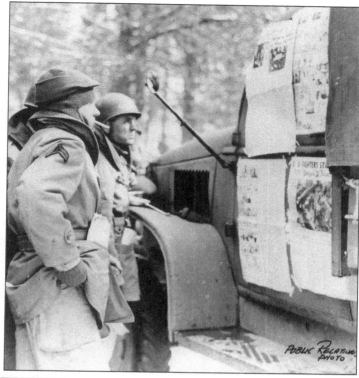

When the 51st Battalion completed the final problem on January 12, the men began a 15-mile trek back to Camp Abbot over icy roads and steep hills. On the following day, Thursday, they celebrated completion of ERTC training with a parade. Friday was final reprocessing and equipment return. Most men enjoyed a furlough before they were shipped to combat assignments, other training, or officer candidate schools. (Courtesy of DHM.)

The basic field problem scenario varied from time to time. During some maneuvers, the Army called on private pilots to "bomb" the troops to simulate enemy gas attacks. Other times, material was delivered at the bridgehead, but had to be withdrawn in the face of "enemy fire." These variations meant the troops had to improvise.

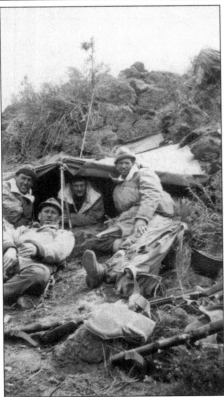

The Army applied lessons learned in recent battles, incorporating them into scenarios for training schools and field maneuvers. Hard-learned lessons from battlefields in Europe and the Pacific played a key role in revising lesson plans at Camp Abbot. As a result, trainees on field maneuvers kept up night patrols, established guard posts, and slept in prone shelters. (Courtesy of DHM.)

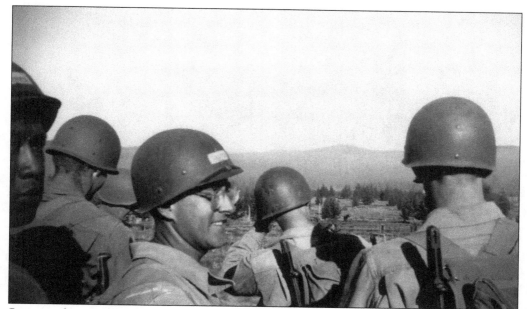

Spring and summer maneuvers proved almost as challenging to the training battalions as winter exercises. The scenario was the same. Enemy troops had landed on Oregon beaches and moved inland. During 17 consecutive days of May 1944, the 51st Battalion was in the thick of it again. This time the enemy had landed in Seaside and Reedsport.

As the field training problem progressed, enemy troops moved eastward to occupy Portland, Salem, and Eugene. According to the scenario developed by Major Joslin and his staff, enemy air forces had bombed Bend and surrounding infrastructure, putting a stranglehold on friendly force movement. As the enemy kept moving east, the engineers took up defensive positions.

61

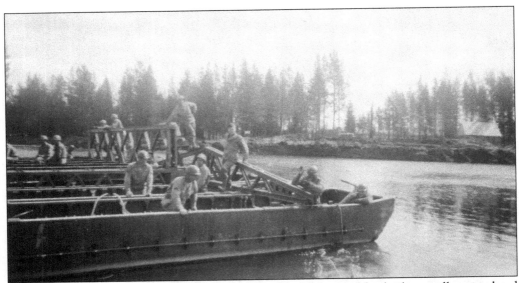

The combat engineers quickly constructed two 200-foot bridges and footbridges to allow simulated friendly forces to cross the Deschutes River and take a stand against the enemy. The bridges had to be ready by 9:00 p.m., when they needed to cross. The engineers were still pounding the last nails into the bridges when the time came. (Courtesy of DHM.)

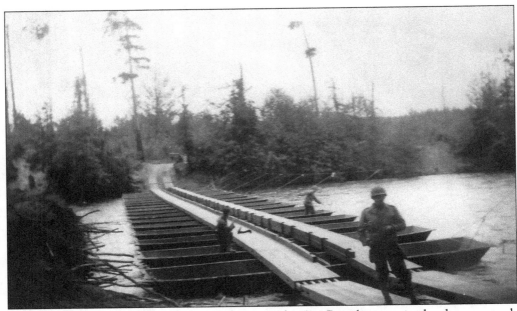

As the last friendly force truck crossed the river, the 51st Battalion received orders to march northward cross-country along the river. At the end of the rugged, forced march, the soldiers had to break out their K-rations of corned beef, a biscuit, and a chocolate bar. Why? According to battalion headquarters, heavy friendly force movements over the bridges the engineers built the previous evening had delayed delivery of supplies.

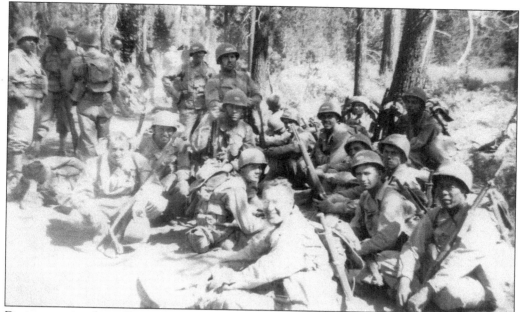

During ensuing days, the maneuvering engineers continued to build defensive positions and lay defensive minefields until news broke that enemy paratroopers had seized an airstrip southeast of Bend. The troops were ordered to quickly build a pontoon bridge across the river. The final problem for the week was to destroy the airfield to prevent the enemy from landing additional troops.

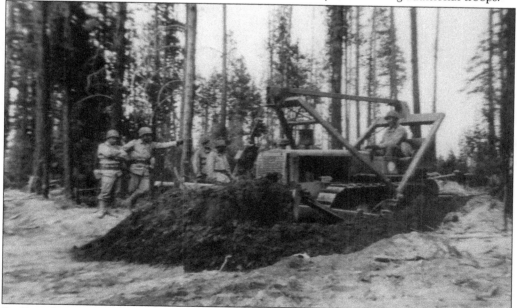

By Saturday evening, the engineers had strung 900 yards of barbed wire across the airstrip and dug several craters to make it impossible for the enemy to land additional troops and material. This completed the final field training problem, and the men returned on foot to Camp Abbot for a good dinner in the mess hall and a good night's sleep in the barracks before graduation and transfer.

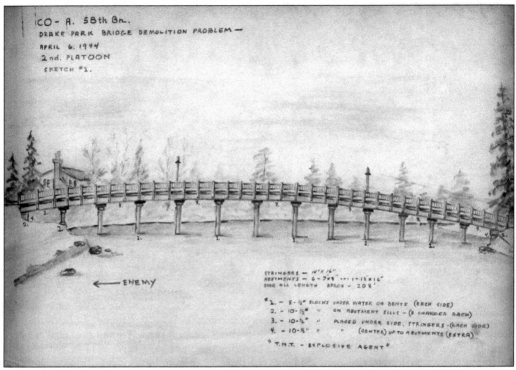

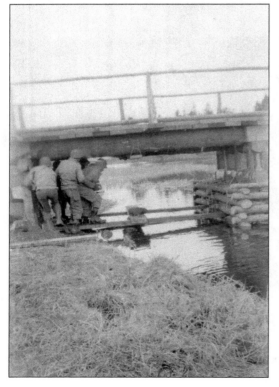

Combat engineers were trained not only to build bridges and roads, but also to destroy infrastructure to hamper enemy movement. The engineers became experts at destroying bridges, many of which they had built themselves. By studying local bridges, they also tried to figure out how best to destroy them. This hand-drawn schematic is a demolition study of Drake Park Bridge in Bend. (Courtesy of DHM.)

Camp Abbot's training grounds included an area in a remote northwestern corner of the reservation for demolition of bridges. Here, trainees practice placing explosives under the abutments of one of the bridges they had built across the Deschutes River. (Courtesy of DHM.)

Colonel Besson originally suggested actual destruction of bridges when he was stationed at Fort Leonard Wood. He tested the idea at Camp Abbot. Using nitrostarch and other explosives, the trainees in this picture are destroying a timber trestle bridge. To minimize environmental impact, the engineers tied heavy cables along the spans to prevent them from sinking into the river.

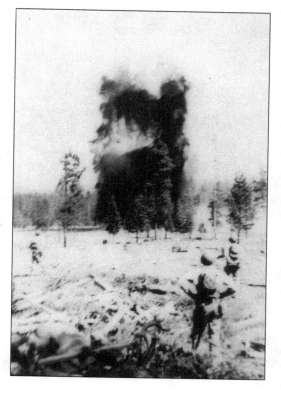

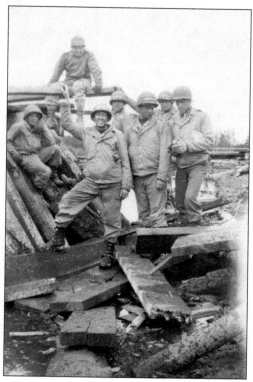

Sitting atop the remnants of a blown-up bridge, trainees celebrate the successful demolition of a bridge built during training exercises at Camp Abbot. It was not uncommon for the engineers to later practice repairing and rebuilding blown-up bridges. In March 1944, Company A-58 blew up a fixed bridge, which was later rebuilt by the entire 57th Battalion. (Courtesy of DHM.)

After successfully completing the intense training at Camp Abbot, most trainees received individual orders to join engineering units requiring replacements. Other were sent to specialist schools or onto officer candidate school. Combat engineers were shipped to Europe to take the place of engineers wounded or killed in action. Camp Abbot–trained engineers took part in many important battles on the way to Berlin. The saying "war is hell" is attributed to US Army general William Tecumseh Sherman during the American Civil War. Camp Abbot training helped most survive that hell. Their common experiences at Camp Abbot forged lasting friendships. Many who survived the war later returned for reunions at Fort Lewis, Washington, and Sunriver, Oregon, the site of the former Camp Abbot. (Courtesy of DHM.)

Five

THE OREGON MANEUVER

In May 1943, Pres. Franklin D. Roosevelt and Prime Minister Winston Churchill met in Washington, DC, at the Third Washington Conference (codenamed Trident) to discuss plans to invade Europe. Early in the war, invasion plans had been targeted for 1943, but at the conference, the United States and Britain decided another year was needed to amass sufficient troop strength and war material for an all-out attack on the German forces in Europe. The two leaders also decided to invade Sicily to engage Germany to open a second front that would force Germany to pull troops away from the Russian front.

In light of the Trident conference, production of war material and training additional troops became top priorities for the Army. Critical to a successful invasion was the ability to coordinate forces and supporting material. America's high command decided to give its commanders and troops an opportunity to practice on a large scale.

In mid-June 1943, *The Bend Bulletin* announced that the Army would conduct large-scale war games in Central Oregon. Named the Oregon Maneuver, the mock war would eventually include more than 100,000 troops and run throughout seven counties in the interior of Oregon, an area larger than the state of New Hampshire. The 10,000-square-mile area included Deschutes, Jefferson, Lake, Crook, Klamath, Harney, and Grant Counties and also included the Deschutes, Fremont, Ochoco, and Malheur National Forests.

The Army immediately began a public relations program to gain the support of private landowners in the area. These included Shevlin-Hixon and Brooks-Scanlon lumber companies, which owned Bend's large sawmills and expansive timberlands. Without exception, the Army received whole-hearted cooperation from local farmers and ranchers. At the same time, the Oregon Game Commission canceled the fall hunting season in the affected areas.

Two weeks after the initial reveal of the Oregon Maneuver, *The Bend Bulletin* announced that Lt. Gen. Alexander M. Patch Jr. had been appointed commander of the IV Corps. Patch established his headquarters at Camp Abbot.

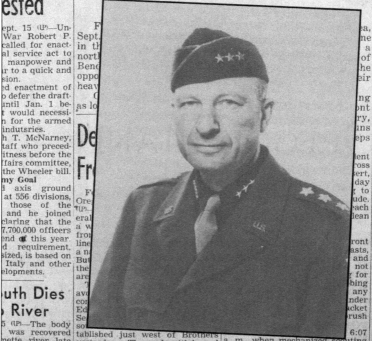

(Continued on Page 7)

Battle Line in Big Maneuver Takes Shape on High Desert

Combat Units Feel Out Strength of Opposing Outfits Near Brothers; Planes "Strafe" Men

Service ested

ept. 15 (UP)—Un-
War Robert P.
called for enact-
al service act to
manpower and
r to a quick and
sion.
ed enactment of
o defer the draft-
until Jan. 1 be-
t would necessi-
n for the armed
indutsries.
h T. McNarney,
taff who preced-
itness before the
ffairs committee,
the Wheeler bill.

my Goal

d axis ground
at 556 divisions,
those of the
and he joined
claring that the
7,700,000 officers
end of this year.
d requirement,
sized, is based on
Italy and other
elopments.

uth Dies River

5 (UP)—The body
was recovered
mette river late
days after the
into the river
t to retrieve an
ad dropped into

Barrick said that
killed instantly
blades of the

Hit

n from field ar-
guns offshore.

tablished just west of Brothers
yesterday. The red withdrawal
placed the front approximately 65
miles east of Bend, Ore.

Bombers Used

While the exact missions of the
opposing armies have not been
disclosed, it was understood the
red units would act as a defensive
command, and the blue forces un-
der Maj. Gen. James L. Bradley
would act as an offensive force.
The blues apparently hold numeri-
cal superiority. However, reserve
forces of the opposing armies
may change the balance.
Both forces have used low-level
bombers against installations, per-
sonnel and transport columns.

a. m., when mechanized scouting
units clashed and aircraft dashed
back and forth in observation and
strafing. Motorized columns many
miles long headed across the
desert as dust rose hundreds of
feet into the air, but the planes
flew right through to strafe.
Troops fired rifle blanks at the
strafers as they swept up the line.

(Continued on Page 5)

State Is Lagging In Bond Buying

Portland, Sept. 15 (UP)—Oregon-
ians today were falling behind the

Salerno D Observed

Deschutes cou
chased a little les
cent of its $1,148,3
third war loan in
the drive's duratio
figures released
Schueler, county
chairman, today.
turns through Tue
$214,377.50 worth
chased to date, in
worth assigned to
the Central Oreg
Credit association.
A telegram receiv
this morning from
state chairman, ask
be declared "Sale
that everyone pu
hilt" on that day i
many boys from Or
ed in life and death
the Germans on th
an battlefield.

Battle Is E

"American boys a
are fighting one o
battles of the war-
be another Chateau
ericans are watchi
crucial Salerno sect
breath," the telegra
requested every ci
his share of the h
home by loaning h
the victory.
Sept. 24 and 25,
town merchant in E
supplies of war bon
on hand to take
from patriotic shop
also announced. Th
under the direction
chants' committee,
and George Childs.

Great A Observe

By John A.
(United Press Staff Co
London, Sept. 15
lied naval activity
past few days off I

By the time Lt. Gen. Alexander M. Patch Jr. took command of IV Corps for the Oregon Maneuver, he had distinguished himself as commander of the famed Americal Division (23rd Infantry Division) during the Guadalcanal Campaign in 1942. While there, Patch was stricken by pneumonia in addition to contracting malaria and having bouts of dysentery. Gen. George C. Marshall, Army chief of staff, ordered Patch back to the United States to recuperate. In May 1943, Patch took command of IV Corps at Fort Lewis, Washington, in time for the Oregon Maneuver. Throughout early July, troops and equipment started flowing into Central Oregon from Fort Lewis, as well as from Camp Adair and Camp White in Western Oregon. In addition, the engineers at Camp Abbot were put on notice to be a part of the maneuver. Maneuver troops were organized as the red force and blue force under the command of Maj. Gen. James Bradley and Maj. Gen. Gilbert R. Cook, respectively. Both men were graduates of West Point.

The area chosen for the Oregon Maneuver offered the opposing blue and red forces a wide range of terrain. Larger than many Eastern states, the 10,000-square-mile Oregon Maneuver area encompassed several mountain ranges and surrounding lowlands vegetated with sagebrush scrub, western juniper, and ponderosa pine.

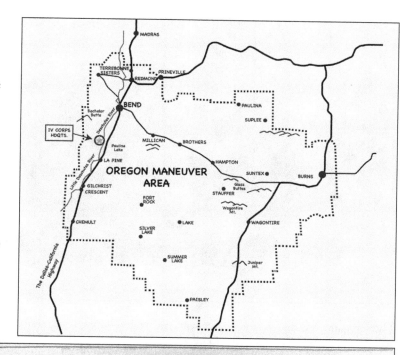

MANEUVER RIGHTS PERMISSION FORM

I grant to the War Department for the duration of the war and six months thereafter maneuver rights upon my real property situate within the area indicated on the map forwarded to me with this card, excepting the portion under cultivation and my dwelling site. In the event of damage I shall have the right to file claim therefor with the Rents and Claims Board established at Camp Abbot.

...
(Signature)

PLEASE PRINT

Name.. Date.......................................
(of person signing permit)

Approximate Acreage............................. Owner's Name.......................................

Owner's Address....................................... Fill in both of these if applicable

Lessees Name.......................................

Lessees Address.......................................

Above is a reproduction of the maneuver rights permission form that land owners in the northwest maneuver area are being asked to sign. The form is printed on a card sent to all known land owners in the area, together with a map and a letter of explanation. On the opposite side appears the mailing penalty notice and the address, "War Department, Ninth Service Command, Rents and Claims Board, Camp Abbot, Oregon." Major E. H. Keene is the officer at Camp Abbot in charge of securing signatures to the permission form and a sub-committee of the chamber of commerce military affairs committee, headed by John Wetle and including K. E. Sawyer, C. L. Mannheimer, George Childs and Ralph W. Crawford, has been named to assist him. The original form is four by nine inches. For newspaper reproduction it has been slightly reduced in size.

In preparation for the maneuver, landowners signed a Maneuver Rights Permission Form to grant the War Department rights to use of their property. The form, together with a letter from the Rents and Claims Board at Camp Abbot, was mailed to area landowners. The letter stated that, in the event of damage to land and property, claims were to be sent to the board for settlement. (Courtesy of DHM.)

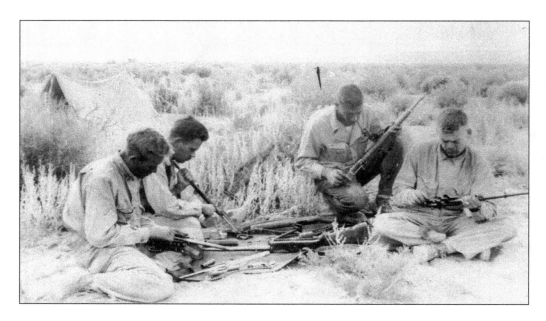

The war game was divided into eight problems, each posing specific challenges for the commanders and their troops. The larger blue force was assigned an offensive role, while the smaller red force conducted defensive maneuvers. Under the watchful eye of 1,500 umpires, the first major battle took place in mid-September in the area around Brothers. Skirmishes between the opposing forces started in the early morning hours on September 14. After intensive battles in the sagebrush-strewn desert near Brothers the following day, the red force withdrew toward Burns, displaying delaying tactics as they fell back. Throughout the maneuver, the two armies also defended themselves against attacking aircraft flying from US Army Air Force training bases in Redmond and Madras, Oregon, which strafed and bombed them. (Both, courtesy of DHM.)

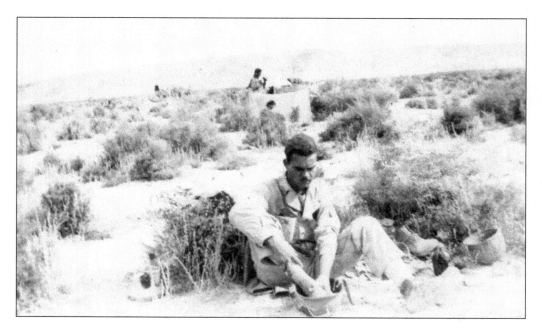

After the first two problems, Col. Frank W. Young, IV Corps medical officer, surveyed troops in the maneuver area to gauge their overall health. As the blue and red forces were critiqued, the red force at Wagontire and blue force at Suntex, Young reported the men to be in good condition. Aside from several reports of ticks and a snakebite, from which the unlucky soldier was recuperating, the dusty and tired men were in good health and enjoying rest and recreation. After several days of simulated combat, the soldiers took to fields and roads to get some sleep. Throughout the war games, the Bend USO club, together with out-of-area USO clubs, provided mobile units to serve the troops in the maneuver area.

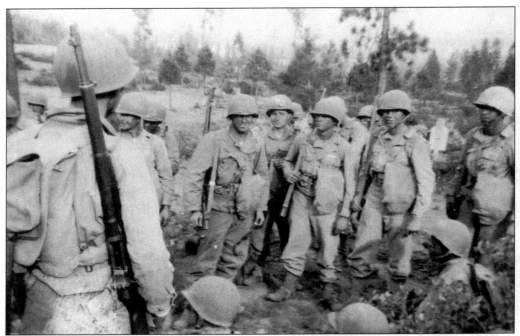

The final problem between the red and blue forces took place on October 30, 1943, on both sides of the Deschutes River in the northwestern reaches of the maneuver area. This action included all 100,000 men. As the battle opened, the blues attacked the reds along a front line that extended from Odin Falls to the Tumalo area. Friday night, blue force elements sneaked over the river to prepare for a Saturday morning assault. Early Saturday, the rest of the force crossed the Deschutes River in assault boats and rafts, and by bridges. The combat engineer trainees from Camp Abbot were in the thick of the assault, building and destroying bridges. The battle drew to a close on October 31, and on the following day, IV Corps packed up and left the area. (Below, courtesy of DHM.)

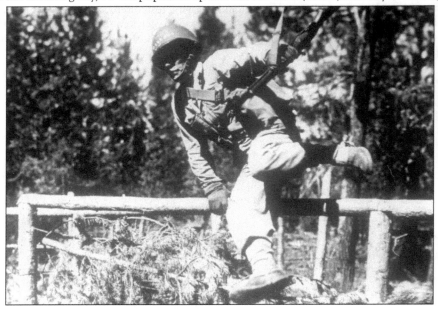

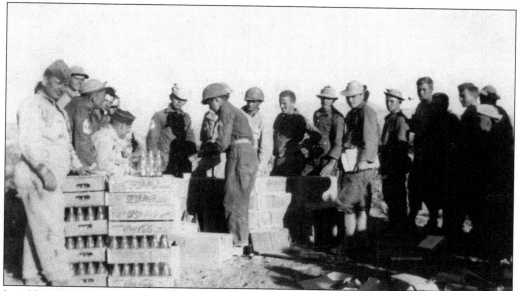

In addition to supplying Camp Abbot, Army logisticians supplied the Oregon Maneuver forces with food, fuel, and ammunition. The logistics were daunting. According to the October 1, 1943, issue of *The Oregonian*, the Army needed 14 million pounds of food to sustain the 100,000 men. Also included were seven million gallons of fuel and lubricants to keep 12,000 vehicles in operation. (Courtesy of DHM.)

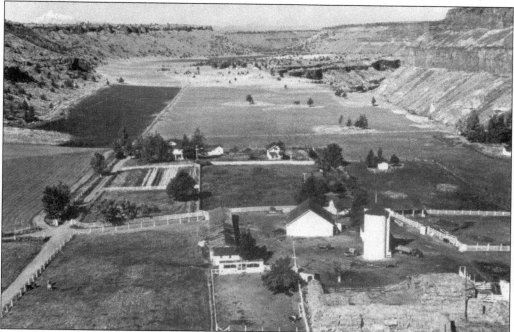

Although the Army supplied the troops with plenty to eat, soldiers were still on the lookout for good meals. GIs bivouacking near the Gates Ranch near the Crooked River are said to have sneaked over to the ranch house in the evenings for home-cooked meals. The field rations provided by the Army proved no match for Mary Lawrence's cooking. (Courtesy of DHM.)

The successful Oregon Maneuver was something to write home about. Following the maneuver, the Army started repairing damaged roads and properties throughout the area. By mid-November, over 3,000 troops remained, patching roads and fences damaged during the mock battles. The IV Corps also left a more tangible gift behind. The soldiers collected over $4,550 to benefit the Deschutes County War Chest. Although 100,000 men took part in the Oregon Maneuver, only 10 fatalities were associated with the buildup of the forces and the actual war games. These were Lt. Sidney J. Gaston, Newark, New Jersey; Pfc. Richard T. Hendrickson, Hagarsville, Arkansas; Pvt. William E. Collins, Oregon City, Oregon; Pfc. Forest W. Millard, Eddy, Texas; T-4 Hugo W. Kauppi, hometown unknown; T-5 Carl R. Carinsky, hometown unknown; Pfc. Andrew C. Gomez Hanford, California; Pfc. Hildred T. Scott, Canto, North Carolina; Pfc. Glen H. Dishman, Mabel, North Carolina; and Pvt. James L. Tollie, Three Mile, North Carolina. (Courtesy of DHM.)

Six

LIVING AT CAMP ABBOT

Camp Abbot was officially dedicated on September 2, 1943, almost a full year after construction began on the Engineer Replacement Training Center. The ceremony was attended by more than 3,000 Central Oregonians and invited guests.

It was a day of celebration. Busses and private cars moved through the camp to view different training scenarios. The camp's white-gloved military police were stationed throughout the streets, making sure traffic flowed smoothly. The curious crowds got to view soldiers practice live fire drills at the rifle range, watch explosions throw up dirt on the demolition field, and see engineers build pontoon and fixed bridges.

The visitors were also treated to a view of the obstacle course, one of the toughest in the Army. Soldiers showed off their expertise in high-jumping, wall-scaling, rope climbing, and other physical training exercises.

The dedication ceremony was held at a newly constructed platform bristling with military brass and civilian dignitaries. Colonel Besson introduced Oregon's junior US senator, Rufus Holman, who ended his speech with a quotation from Shakespeare: "Thrice armed is he whose cause is just."

Gen. Alexander Patch, recently returned from action in the South Pacific, and commander of the Oregon Maneuver, told the men, "Camp Abbot affords you men the best possible training facilities. Now—if you men will get everything you can from what is afforded here, and train yourself morally for the battles ahead, you will be ready for anything the enemy can provide."

Before the benediction was read by Camp Abbot's head chaplain, Maj. William Andrew, Colonel Besson read letters of good wishes from Oregon governor Earl Snell, Sen. Charles McNary, and Marion Abbot, daughter of Brig. Gen. Henry Larcom Abbot, whose name was attached to the post and who had camped in the area 88 years before.

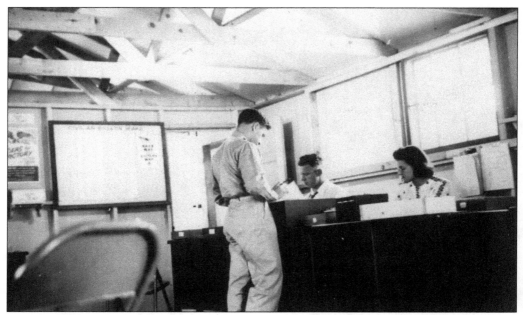

In early April 1943, the Army moved to hire civilian workers (above) to supplement military personnel (below) on Camp Abbot's staff. Lt. Col. Robert Dicey, Colonel Besson's predecessor as post commander, set out to employ between 600 and 650 civilians to assist with administration and maintenance duties. Among the more critical needs were at least 150 laundry workers to ensure clean uniforms and bedding for 10,000 officers and men at the ERTC at any given time. Also needed were civilian administrative assistants as well as purchasing, commissary, and transportation clerks. Other jobs included shoe repairmen, communications operators, machinists, shop clerks, chemists, heating plant operators, road maintenance crews, a fire chief and assistant, typists, and stenographers. Salaries ranged from $960 per year for manual labor positions to $3,000 per year for skilled positions. (Above, courtesy of DHM.)

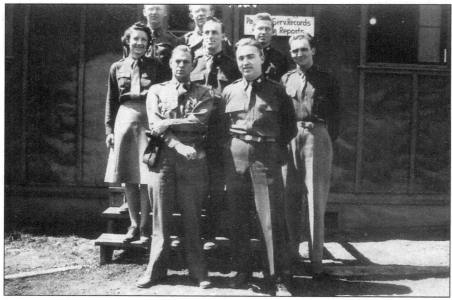

Like any self-respecting city, Camp Abbot had its own newspaper. Colonel Besson gave thumbs up for the publication of a four-page tabloid. The first issue of the weekly *Abbot Engineer* was published on May 22, 1943. Published under the supervision of the post special services branch directed by 1st Lt. Paul O'Brien, the paper was edited by Pvt. Morris Guss. His staff included six enlisted personnel. The newspaper was printed on *The Bend Bulletin* press in Bend. As the camp grew and there was more news to report, the newspaper expanded to eight pages. The *Abbot Engineer* featured a brisk mix of camp news and sports activities around the post, information about insurance programs or war loan drives, entertainment, pictures of pinup girls, and cartoon strips. The paper also featured photographs by post photographer Dale Vincent. (Courtesy of DHM.)

Colonel Besson, his staff, and Camp Abbot soldiers endeared themselves to citizens of Bend by supporting war bond drives and other fundraising initiatives. Colonel Besson accepted a check for $1,668.89 from Maj. Paul Diediker for the 1943 Christmas Seal drive, donated by the personnel and soldiers at the camp.

The community also held other staff in high regard. When Lieutenant Colonel Harvey (second from left) was reassigned in August 1943, *The Bend Bulletin* published an editorial headlined, "A Friend Leaves." The editorial complimented "Del" Harvey's management of Camp Abbot construction, which it likened to "a four-ring circus with a couple of side shows thrown in." Harvey also oversaw construction projects at Redmond and Madras air bases.

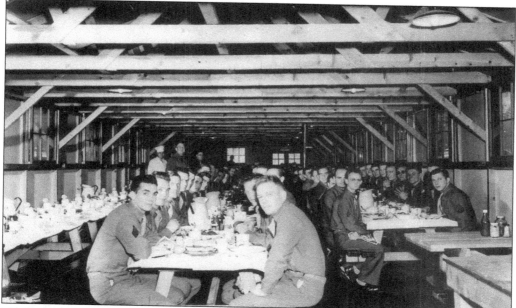

While training at the post rather than in the field, soldiers enjoyed their daily three square meals prepared and served in Camp Abbot's mess halls. This wood-framed mess hall featured low-hanging roof trusses, well-functioning picnic tables, and contrasting white tablecloths and china.

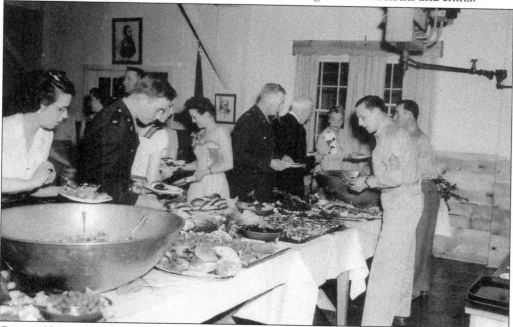

Camp Abbot's officers and their ladies enjoy a buffet dinner at the officers' mess under the watchful eye of ERTC's namesake, Brig. Gen. Henry Larcom Abbot, who is featured in the portrait above the window at left. Colonel Besson (center, pipe in mouth) found this officers' mess "entirely inadequate" and immediately planned construction of a more fitting facility. On the wall to the left of Colonel Besson is a photograph of Gen. Dwight D. Eisenhower.

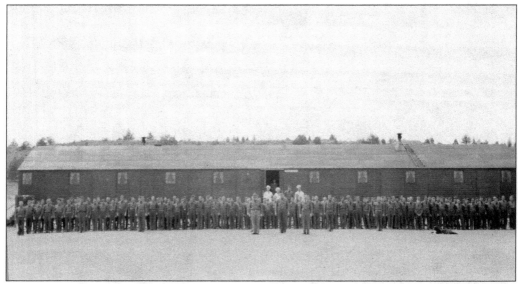

One of the more important challenges faced by Camp Abbot administrators was feeding about 10,000 military personnel. Food deliveries arrived daily by railroad, and meals were prepared in mess hall kitchens. That provided what the *Abbot Engineer* called "the biggest item in American morale . . . good chow" even as it disparaged "Army breakfast, of unprintable name, composed of some kind of ground up sausage in gravy smeared on toast." (Courtesy of DHM.)

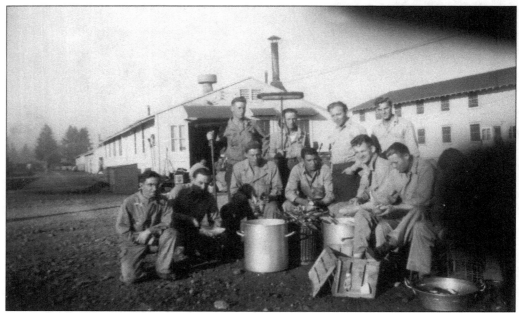

A trial by fire of sort, no rookie soldier managed to escape "kitchen police" duty, or KP, which included washing dishes, mopping floors, carrying 500 pounds of ice, and peeling potatoes. Eventually, every private on the post was assigned to KP duty, which was also meted out by drill sergeants as punishment for goofing around or such infractions as forgetting to shine one's shoes or collecting dust under the bed. (Courtesy of DHM.)

As many soldiers could attest, KP was not the most glamorous part of Army life. According to an article in the July 30, 1943, *Abbot Engineer*, "there is something about peeling potatoes, that stimulates conversation. . . . To hear a KP talk over a potato bucket you would think he was Lothario and Jack the Ripper rolled into one. His expositions will go all the way from victory in a ballroom fight, to the night with a blonde from Sandusky on the pier at Redondo." Pictured is cook Sgt. Cody Thompson of Shreveport, Louisiana. (Courtesy of DHM.)

Camp Abbot had one main chapel and three auxiliary chapels where Army chaplains attended to the soldier's Protestant, Catholic, or Jewish religious needs. The services were well attended by both officers and soldiers. Chaplains cycled in and out of Camp Abbot throughout the ERTC's 14 months in existence. 1st Lt. David I. Segerstrom was the third clergyman to join the camp in May 1943. Recently graduating from chaplain school at Harvard University, Segerstrom was a 22-year veteran pastor from Massachusetts. He joined senior chaplain Maj. William Andrews and 1st Lt. Vernon C. Cooley. Other camp chaplains included Capt. Norman H. Goldberg, who performed the invocation at the dedication ceremony on September 2, 1943.

Off-duty soldiers had plenty of opportunities to practice the time-honored skill of writing letters. Camp Abbot dayrooms provided a quiet place away from the barracks to write to parents, wives or girlfriends, sisters or brothers, at other posts in the United States or fighting overseas. In cooperation with Bend's post office, the camp ran a busy substation. Mail was delivered to Camp Abbot's branch post office operated by 13 enlisted men and civilians. During its first month of operation, the Camp Abbot post office handled 175,000 incoming and 70,000 outgoing letters, a daily average rate of 8,000 letters. At the same time, money orders to the tune of $7,000 were written during the month of May 1943, or $7 a minute, according to the camp postal officer, Capt. John Burgerson. (Courtesy of DHM.)

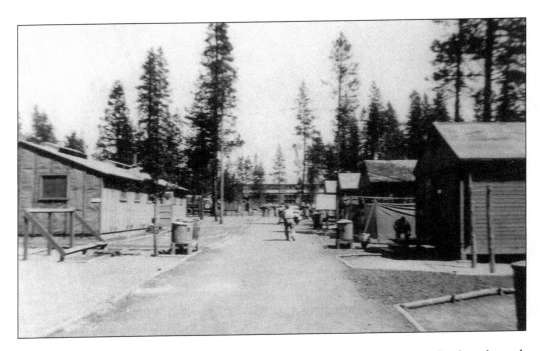

The hustle and bustle of Camp Abbot was always present. The enlisted men lived in large barrack complexes intermingled with training areas, bayonet courts, and a small obstacle course. The barracks were arranged in four large quadrants intersected with dusty streets named "A" through "L." Even though the Army had designed a well-functioning military reservation, the citizen-soldiers tried to make the best of the situation and make sure Camp Abbot had a small-town feel. Today's urban planners would have frowned upon the design of the base but would have complimented the Army for saving the trees in the cityscape.

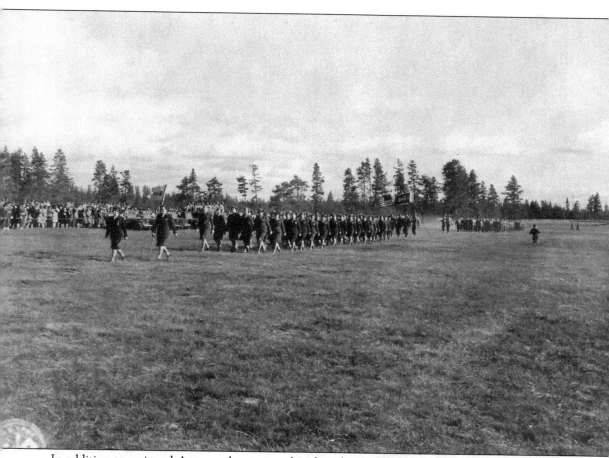

In addition to assigned Army male personnel and civilian employees, a contingent of Women's Army Auxiliary Corps personnel, or WAACs, reached full strength at Camp Abbot by the end of May 1943. A total of 155 WAACs were assigned to 20 different jobs including administrative, medical, motor pool, and other duties for which they had trained at several bases in the South. In July 1943, their corps was renamed Women's Army Corps, or WAC. The WACs led lives similar to their male counterparts. After staying in barracks originally built for enlisted men, the WACs were billeted in new quarters. An administration building, a mess hall, and a post exchange supplemented their two-story barrack buildings. Their sleeping quarters were equipped with conveniences male soldiers could wish for only in their wildest dreams. WACs slept between real sheets, and their bathrooms had individual showers and bathtubs. The women no longer had to do their laundry in the showers and hang the clothes out on tree limbs to dry.

Camp Abbot's theater offered staff and trainees entertainment ranging from skits put together by soldiers to performances by nationally known celebrities. Hollywood matinee idol and for-the-duration Coast Guard chief boatswain's mate Victor Mature entertained the troops in February 1944 with a variety show featuring skits including "Sad Sack." A nationally syndicated cartoon strip created by Sgt. George Baker, "Sad Sack" depicted a private and his experiences with military life. Throughout the show, the character Sad Sack was "interviewed" by Chief Mature. Members of the ERTC dance band, under the direction of Cpl. Agho Tiemann, shared the stage. Mature performed the same show at the Tower Theater in Bend later that week.

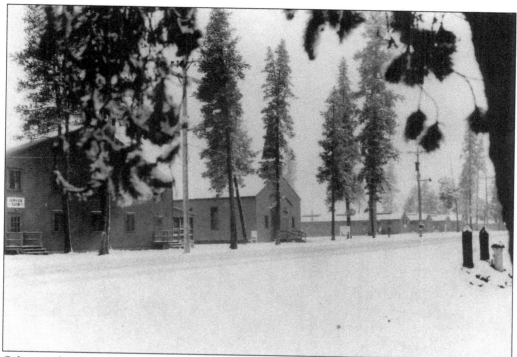

Other weekend entertainment included dances at the camp's USO club, located to the left in this snowscape. The first dance for enlisted men was held on May 27, 1943. Bend sent 75 junior hostesses to the dance. The Army supplied transportation, which prompted the senior hostess chairwoman, Ruth Coyner, to issue a decree to the girls to wear washable dresses "as it may be a dusty trip."

To sway the hearts of Bend's residents, the USO club on Wall Street featured entertainment by soldiers and WAACs from Camp Abbot. The talented WAACs appeared at the club on June 3 with a show called "WAACs at Abbot." The half-hour variety show also included the ERTC dance band. Over 750 people crammed into the Bend USO to watch, and local radio station KBND broadcast the program via live remote. (Courtesy of DHM.)

Camp Abbot was not all work. After a day on the obstacle course, on an 11-mile march, or learning to assemble a pontoon bridge across the Deschutes River, trainees could relax in one of the six large dayrooms equipped with comfortable furnishings and plenty of books, magazines, games, ping-pong tables, and other recreational equipment. Bend citizens donated many of these amenities. The camp also offered plenty of activities to harness the energy of the young soldiers. Many barracks had their own softball teams. The soldiers also formed baseball, basketball, volleyball, bowling, and boxing leagues, or enjoyed classes in fencing and judo. The *Abbot Engineer*'s weekly sports pages kept track of base sports statistics.

The ERTC had much in common with small-town America. This included the Camp Abbot baseball team. Located on Fourth Avenue, the baseball field was equipped with regulation backstop, sliding pit, and two bullpens. The team boasted former professional and semiprofessional players. The Percy A. Stevens American Legion post in Bend provided brand new uniforms for the team. On Sunday, June 13, the Abbot Engineers faced the Bend Elks in their first "official" game. *The Bend Bulletin* termed the Abbot Engineers a strong nine for the Sunday game. After their 11 to 1 loss to the Elks, the reporter who covered the game characterized the Abbot team as "still in its formative state." The score was one-sided, but the reporter still claimed the team "provided plenty of opposition for the Bend squad." Although the soldiers were receiving excellent military training, they had little training at playing baseball as a team.

Camp Abbot officers were sought-after speakers. Whether it was talks for the chamber of commerce or service clubs about the war or Camp Abbot's training regimen, the ERTC officers drew large crowds. Local radio station KBND broadcast special programs and concerts featuring Camp Abbot officers, soldiers, and WACs. Col. Frank Crandall, the post's surgeon, was a favorite speaker, as were Maj. Russell Turrill and Lt. Paul O'Brien. Many of these speakers are shown above. From left to right are (first row) Lt. Col. C.J. Douglas, Col. L. Hall, Col. Frank S. Besson, and Lt. Col. Merril Pimentel; (second row) Maj. Paul Diediker, Major Terrill, Maj. M.J. Cuadra, Capt. A.A. English, and Lt. W.F. Pascoe. Below is Col. Frank Crandall with Red Cross and Army nurses. (Both, courtesy of DHM.)

Seven

ON THE HOME FRONT

With a population of just over 10,000, Bend in the early 1940s was Central Oregon's largest town. The two largest employers in this one-industry timber town were the Shevlin-Hixon and Brooks-Scanlon lumber mills, which together employed around 3,000 people. According to an advertisement in *The Bend Bulletin* in September 1939, a total of 2,447 of Bend's households read the newspaper.

World War II had a profound effect on American households. Two months before the Japanese attacked Pearl Harbor on December 7, 1941, the Office of Price Administration (OPA) was established. Its original function was to institute price and rent controls, but it became a powerful agency that controlled prices and rationed commodities deemed critical to the war effort.

Daily life was mired in ration books and juggling ration points to put food on the table. Under slogans such as "Help Your OPA Fight Inflation," products including sugar, coffee, meats, nylon stockings, and shoes were rationed. Unless a person had important business outside his hometown, he might as well stay put, because gasoline, tires, and automobiles were rationed as well.

The establishment of Camp Abbot offered both pros and cons. The influx of construction workers and personnel benefitted the local economy, as did the number of civilian jobs offered at the military reservation. Stable jobs had been scarce during the Great Depression, and Camp About brought plenty of job opportunities. However, the sudden addition of 10,000 people to the area strained Bend's infrastructure. There was even some resentment of living in a rationed economy while soldiers had access to a seemingly endless supply of food.

Bend citizens took the challenges in stride. They enjoyed the sudden big-city feel that came with the influx of men from all over the nation and doted on the soldiers from Camp Abbot. Housed in the old Safeway building on Wall Street, the local USO club became a gathering place for soldiers and a source of entertainment for Bend residents.

162195 D

4

UNITED STATES OF AMERICA
OFFICE OF PRICE ADMINISTRATION

WAR RATION BOOK FOUR

Issued to ___Mabel L Bennett___

(Print first, middle, and last names)

Complete address ___Rt 1 Box 648___

___St Helens Ore,___

READ BEFORE SIGNING

In accepting this book, I recognize that it remains the property of the United States Government. I will use it only in the manner and for the purposes authorized by the Office of Price Administration.

Void if Altered ___Edgar L. Bennett___

(Signature)

It is a criminal offense to violate rationing regulations.

OPA Form R-145 16—35570-1

"We'll have lots to eat this winter, won't we Mother?"

**Grow your own
Can your own**

Food rationing by the OPA was a major fact of wartime life. Households all over the country were issued ration books that introduced a point system for groceries and other goods. *The Bend Bulletin* published ration calendars to help housewives keep track of when points came due. "Meatless Mondays" and "Wheatless Wednesdays" became rallying cries to support the war effort.

To increase local food production, the War Food Administration encouraged "victory gardens" with posters such as this. In Bend, as in communities across the nation, homeowners planted backyard gardens to grow vegetables and fruit. Home canning also became a national phenomenon as a way to preserve what the victory gardens produced.

With a little help from Uncle Sam, Bend restaurants flourished during the war years. Off-duty Camp Abbot soldiers traveled to Bend to take in the sights and have lunch at one of the local eateries. The Pine Tavern and other restaurants saw an upsurge of restaurant-goers in military uniform. This was not without its challenges; even the restaurants battled rationing. Pine Tavern owner Maren Gribskov started the restaurant in 1936, in the middle of the Great Depression. During the war years, her niece Shirley Ray was in charge of the day-to-day operations of the restaurant. "We were always short and overdrawn [on ration coupons]," recounted Ray. "We borrowed points from our customers. If they weren't going to use their sugar coupons they brought them in for us to use." Ray remembered a time when her aunt Maren went to the coast on vacation. "Don't call me if they haul you off to jail," she told me. "It's your problem. I don't want to hear about it." (Courtesy of DHM.)

Bend's USO club provided a home away from home for visiting soldiers. The club was officially staffed at the end of May 1943, when assistant director Ann McLaughlin and regional supervisor Marie Thompson arrived in Bend from Seattle. After being used as a grocery store, and more recently as the Camp Abbot information office in Bend, the building was in need of a major renovation. Estimated at $20,000, officials in Washington, DC, quickly approved the request. Bend folks donated equipment to the USO club. Desks, couches, chairs, and even a sewing machine were dropped off at the former Safeway store. The USO center was put together in one day thanks to 75 local women who transformed the lower level into a welcoming place. The building is visible to the left of the Piggly Wiggly store. (Both, courtesy of DHM.)

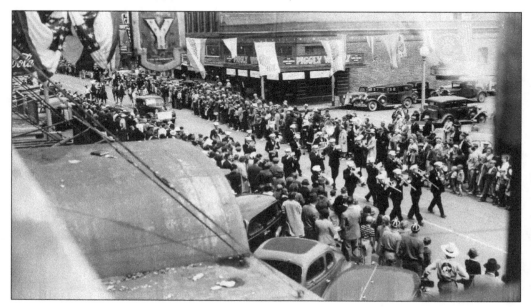

Joyce Armstrong, one of many Bend girls who welcomed visiting soldiers, remembered, "The soldiers came in from Camp Abbot where they were training before going to war. The USO was formed to give the young soldiers something to do outside their training regimen. We sang and danced. We were all old enough to enjoy dancing with young men in uniform. We also played cards and board games, and put puzzles together. My mother volunteered to be a chaperone to keep an eye on all of us girls. . . . If my parents had any questions about a young man's suitability, my mother would invite him home for dinner. I dated a few of them. I can't remember this fellow's name, but we wrote each other until the war ended." (Both, courtesy of DHM.)

Camp Abbot soldiers were frequent visitors to Bend. The Pilot Butte Transit bus company operated a daily schedule to and from town. A round-trip ticket cost 50¢ for soldiers and 60¢ for civilians. The local USO club was a popular hangout, as were the many restaurants in Bend. Community leaders and camp commanders encouraged friendly relations between residents and soldiers. *The Bend Bulletin* successfully encouraged townspeople to invite a soldier to Thanksgiving and Christmas dinners. The picture above shows young Bend resident Pat Metke with two visiting Camp Abbot soldiers. Friendships also developed at Camp Abbot when local residents were invited to visit. (Above, courtesy of DHM.)

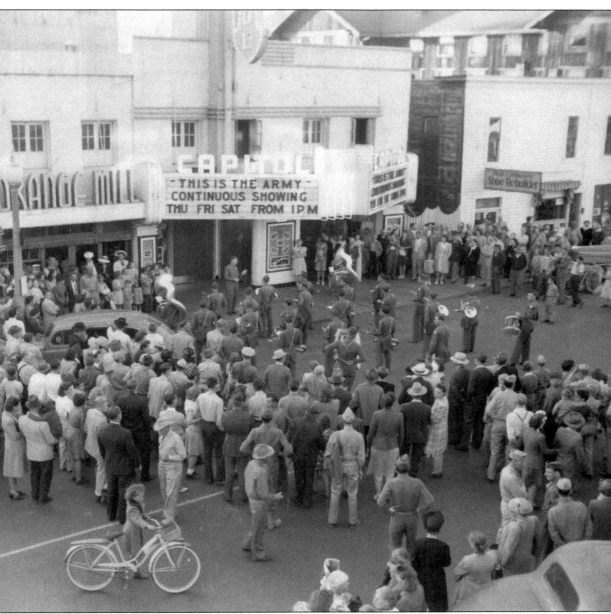

Irving Berlin's musical *This is the Army* got New York's usually cautious movie critics to lend their full support to a screen adaptation of his patriotic stage show. When it came time to turn the show into a screenplay, the Army lent its support by granting the use of several actors, among them Lt. Ronald Reagan (future US president) and Sgt. Joe Louis. The movie starred George Murphy and Joan Leslie. Berlin wrote 19 songs for the movie, including "God Bless America" and "Oh! How I Hate to Get Up in the Morning." The movie opened in Bend on August 18, 1943, at the Capitol Theater to a sold-out house of 560. The Army pulled out all stops at the opening. Camp Abbot's marching band, under the direction of Warrant Officer C.S. Spalding, presented a 20-minute concert outside the theater as moviegoers arrived. *This is the Army* eventually grossed over $9.5 million nationally, which was donated to the Army Relief Fund. The movie pulled in $2,000 in Bend.

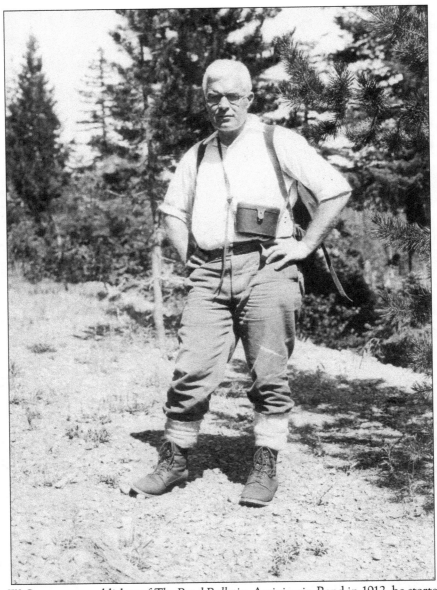

Robert W. Sawyer was publisher of *The Bend Bulletin*. Arriving in Bend in 1912, he started out as a laborer at one of the local mills. After Sawyer wrote unsolicited articles for *The Bend Bulletin*, then owner George Palmer Putnam hired him to be associate editor. When Putnam became private secretary to Oregon's governor, James Whithycombe, Sawyer stayed with the paper and bought Putnam's share in 1919. A community-minded editor and publisher, Sawyer held several positions in local and state organizations and commissions. He served as a Deschutes County judge from 1920 to 1927, a member of the Oregon Highway Commission between 1927 and 1930, and chairman of the Bend Chamber of Commerce's military committee during the war. Over the years, Sawyer became interested in local and state history. When it came time to name the newly proposed ERTC, Sawyer suggested the name Abbot honoring the famous Army engineer who camped along the Deschutes River in 1855. Sawyer wrote many editorials supporting the decision to establish Camp Abbot. In return, he was an honored guest at the camp. (Courtesy of DHM.)

Eight

BUILDING THE OFFICERS' MESS

The largest single undertaking in the history of Camp Abbot may well have been the construction of the officers' mess, which, to this day, remains the most significant remnant of the World War II training facility. Col. Frank Besson envisioned the project only three weeks after the official opening of the ERTC on May 1, 1943.

Colonel Besson related the story at the dedication of the officers' mess almost 11 months later. "In the early days of Camp Abbot, it was discovered that the officers' mess building was entirely inadequate. Immediately, plans were made to build an addition that would properly serve the needs of the officers and their families."

Designed by Capt. John Banks, construction of the new officers' mess began in earnest in October 1943. Building materials for the mountain-style lodge were sourced locally. The structure was built from ponderosa pine, western larch, and white fir, which were readily available in the forests around the camp. The two fireplaces on either side of its great hall were constructed from rocks quarried near Bend.

Classified by Colonel Besson as a "training project," construction was supervised by Maj. LeCompte Joslin, head of the training division. The project took six months to complete, and along the way most Camp Abbot trainees were involved.

The officers' mess at Camp Abbot was dedicated on April 29, 1944. At the dedication, Colonel Besson remarked, "The result is a tribute to the spirit and skill of the entire camp. The old 'Abbot Habit' has triumphed again through the application of the traditional motto of the Corps of Engineers, 'Essayons!' . . . It will be a standing monument to you and to the training received at this center."

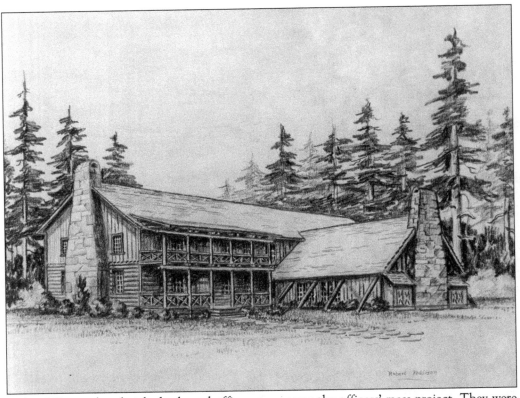

Colonel Besson hand-picked talented officers to oversee the officers' mess project. They were Major Joslin, director of training, as project leader with the help of Capt. Smiley Raborn, chief of school branch; Capt. Carl Strong, chief of operations section; Capt. John Banks, who was in charge of design; Capt. Howard McKeown, in charge of construction; and 1st Lt. James Rodgers, in charge of logging operations.

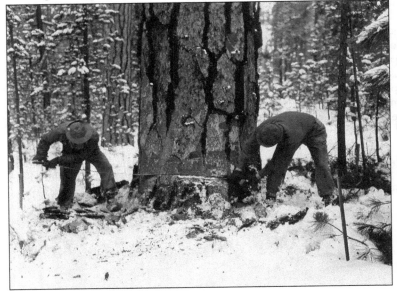

Construction of the officers' mess began on October 1, 1943, with the clearing of the building site. Soon after, crews moved into the forest and began selecting trees needed for the structure. These soldiers are cutting the ponderosa pine that eventually supported the building's large spiral staircase.

Snow started falling in the eastern Cascade foothills in mid-October. Although the winter of 1943–1944 proved less harsh than the previous year, the engineers still had to deal with several inches of snow. Many of the soldiers were skilled woodsmen. The use of chainsaws made the work move along quicker. Here, the men are bucking a log to a specified length. (Courtesy of DHM.)

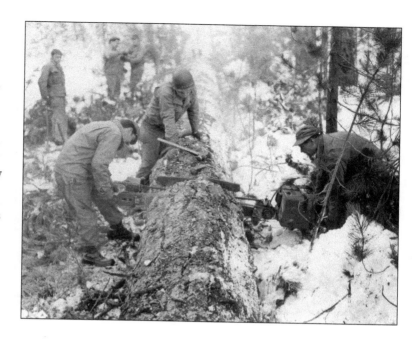

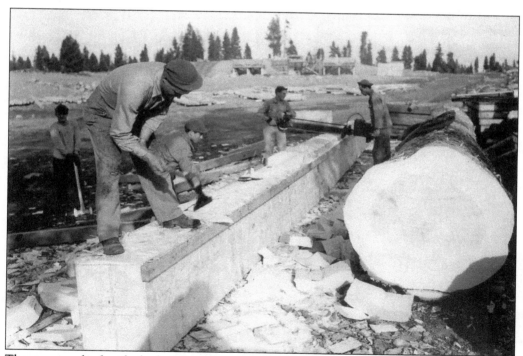

The men involved with the building project used the same hand tools and rigging skills taught during bridge building. Reliance on the adze and other hand tools as well as a two-man chainsaw is highlighted in this photograph. This log was eventually cut and hewn into the four beams marked at the end of the trunk. Aside from hand-hewn logs, the camp's sawmill cut lumber for scaffolding and interior structures.

Camp Abbot's heavy equipment detail received plenty of training during the officers' mess project as it amassed and assembled log components fashioned from more than 500 logs and other building materials. Here, the large centerpiece log for the spiral staircase is lifted into place.

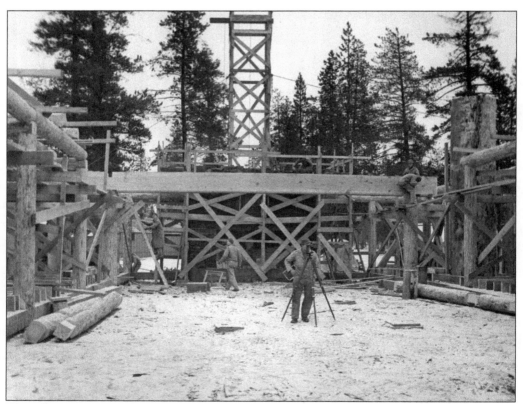

The officers' mess slowly took shape. To the far right, the large tree trunk that supported the spiral staircase is visible, and in the center, the scaffolding for one of the two fireplaces can be seen. A hoist has been erected at each fireplace to lift the heavy stones into place.

The centerpiece fireplace was constructed from lava rocks quarried near Bend. According to Corporal Shimakey, who supervised the stone-laying project, the total weight of rocks used for the fireplaces was estimated at nearly 200 tons. The dark rocks were squared and trimmed by hand, with some of the pieces weighing as much as 900 pounds. The main fireplace weighed in at 110 tons.

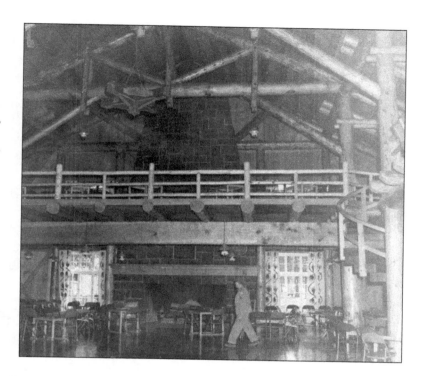

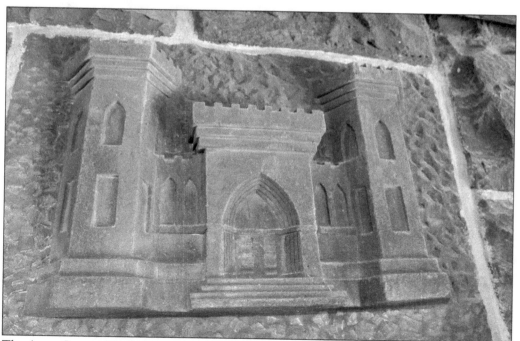

The Army Corps of Engineers insignia featured on the front of the main fireplace was carved by Pvt. Elmer E. Klotz. "This lava rock dries out to a dark grey in color and is similar in hardness to flagstone. It's fairly easy to work and frequently has a grain in it," remarked Klotz, a skilled stonecutter in civilian life. (Author's collection.)

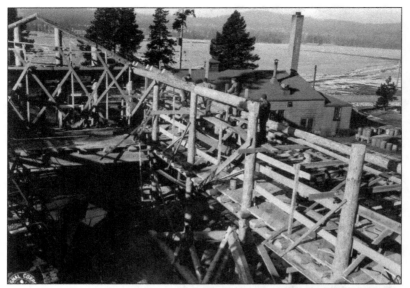

As the second-story balcony that eventually overlooked the main floor of the officers' mess took shape, the builders enjoyed a view of the Deschutes River meadow in the foreground and Bachelor Butte in the background marred only by the original officers' mess structure.

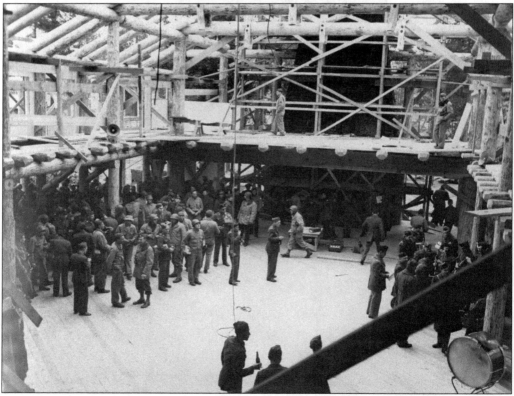

A "bush raising" ceremony was performed in late December 1943. Following an English roof-raising tradition, the ceremony celebrated completion of the roof without loss of life or limb. The bush was hauled up from the floor by rope, then nailed to one of the exposed roof trusses. Although English custom was for everyone to get drunk, the soldiers celebrated the occasion with 3.2 percent beer.

The officers' mess was one of Colonel Besson's pet projects, and he inspected its construction first-hand. The final cost of the officers' mess was $4,796 for material not readily available locally, such as cement, windowpanes, plumbing fixtures, and paint. Another $815 was spent on labor for installing windows and fixtures. The finished building measured 50 by 96 feet.

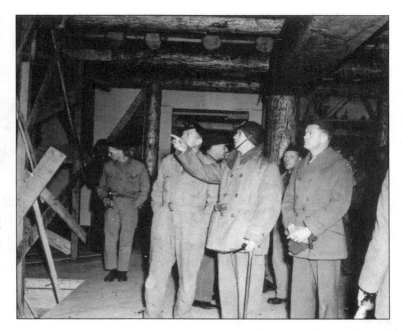

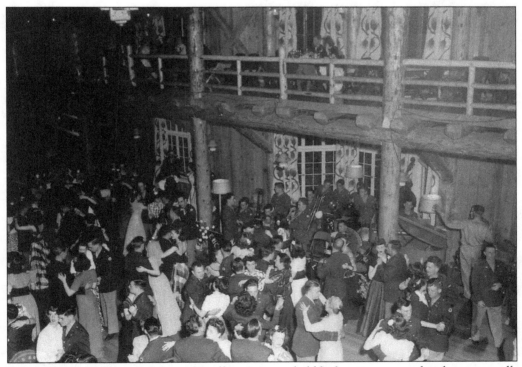

The first and only major event at the officers' mess—held before it was completed—was a well-attended New Year's party for Camp Abbot's officers and their families. The camp's USO club also held a dance for the enlisted men on the same evening. Bend's junior USO hostesses attended, chaperoned by Laura F. Emard and a group of senior hostesses.

Camp Abbot ran a large woodshop. Much of the furniture for the officers' mess was handmade by skilled carpenters under the supervision of the carpenter foreman, Sgt. Joseph Krejci. The furniture was designed by Pvt. James Maguire.

Perhaps a forerunner of living room conversation pits favored by residential architects in the mid-1960s, this specially designed seating promoted camaraderie as it invited enlightening conversations.

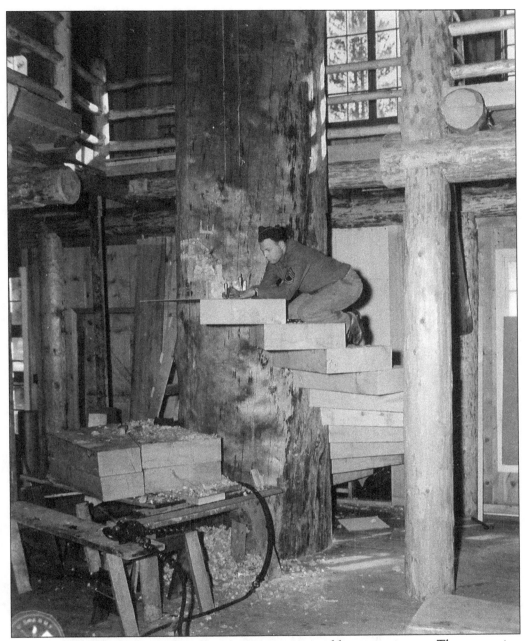

The second-story balcony in the officers' mess was accessed by two staircases. The supporting structure for the east staircase was a single, 56-inch-wide ponderosa pine log that was anchored to a cement base beneath the main floor; it supported spiraling steps to the second floor. Each individual step was handmade and perfectly fit in place by skilled tradesmen. A curved balustrade was eventually fitted to the stairs to provide safety without obstructing the view of the rest of the interior. The balcony was made of oiled native logs securely supported by two 40-foot long, 24-inch thick beams at either end of the great hall.

The officers' mess was completed in April 1944 and was dedicated on April 29 with all the pomp and circumstance worthy of an official building. The event got underway with cocktails and was followed by supper an hour later. The official program began at nine o'clock with brief remarks by Colonel Besson, Major Joslin, and honorary guest Robert W. Sawyer, publisher of *The Bend Bulletin*. Camp Abbot's bands, under the direction of Staff Sgt. Jack Hayes and Cpl. Agho Tiemann, furnished music for dancing and entertainment. The highlight of the evening was a flute solo performed by Sgt. Dante Di Thomas on an instrument donated to the camp by Marion and Elinor, daughters of Brig. Gen. Henry Larcom Abbot.

Nine

CLOSING CAMP ABBOT

On June 6, 1944, the Allied armies crossed the English Channel in an all-out assault on German forces in France. After a precarious D-Day landing, the American, British, and Canadian forces gained a toehold along the beaches of Normandy. Many of the combat engineers who had trained at Camp Abbot accompanied the invasion forces through France and Germany, facilitating the advance as they were trained to do. Other Camp Abbot graduates supported operations against German forces in North Africa and Italy.

With the war in Europe in high gear, the War Department decided to streamline training activities for greater efficiency. Only 14 short months after the dedication of Camp Abbot, Colonel Besson received orders to move the entire operation to a new US Army Service Forces Training Center at Fort Lewis, Washington.

Rumors of the impending transfer had been ebbing and flowing through Camp Abbot before the invasion of France. The official order to close the ERTC came on Wednesday, June 5, the day before D-Day. In addition to the combat engineers, the transfer included Medical Corps and Signal Corps units.

The last issue of the *Abbot Engineer* was published on Saturday, June 17. The headline said it all—"Goodbye Abbot . . . Hello, Ft. Lewis." The newspaper even teased that the "new post has swimmin' hole 'n' everything." The article also mentioned that Fort Lewis was only an hour away from a major city, Seattle.

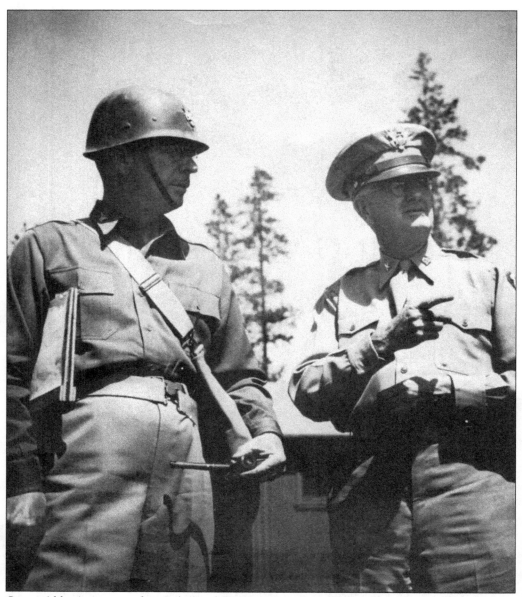

Camp Abbot's commander, Col. Frank Besson, was also transferred to Fort Lewis, where he commanded the US Army Corps of Engineers Training Section of the Army Service Forces Training Center. It was his final station. Colonel Besson retired from the Army in September 1945 after 40 years of service. He was remembered as a tough but fair commanding officer. Besson and his wife, Jeanie, settled in Portland, Oregon, where he joined his brother Dr. John Besson, formerly of Bend, and his family. Colonel Besson died on July 19, 1956, after a long illness, and was buried at West Point. The family's Army legacy was passed to his sons, Maj. Gen. Frank Besson Jr. and Lt. Col. Robert Besson. Here, Colonel Besson (left) is pictured with Brig. Gen. Clarence Sturdevant.

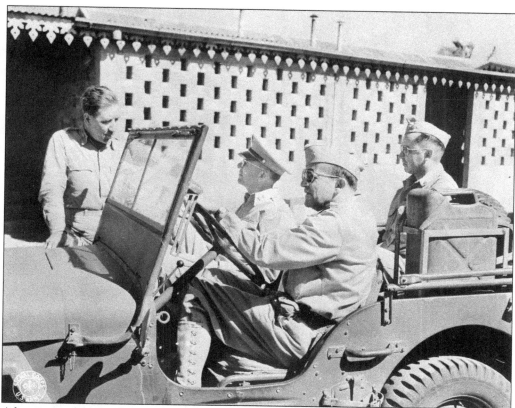

After successful completion of the Oregon Maneuver, Gen. Alexander "Sandy" Patch, pictured in the front passenger seat, was sent to command the IV Corps in Europe in early 1944. In March 1945, Patch assumed command of the 7th Army, which distinguished itself during the Vosges Mountains campaign of October 1944 through January 1945. General Patch died on November 21, 1945. (Courtesy of Library of Congress.)

Camp Abbot's headquarters building was located on Fourth Avenue where Colonel Besson and his staff could look out over the parade ground, rifle range, and training grounds. From this vantage point, the ERTC commander personally monitored the health, welfare, and training progress of his men. (Courtesy of DHM.)

Never meant to be a permanent installation, the Army began dismantling Camp Abbot immediately after the troops left for Fort Lewis. Except for the newly constructed officers' mess, most of the buildings at Camp Abbot were either sold as surplus or razed. The infrastructure of the small city, including water and sewer lines, was left behind. (Courtesy of DHM.)

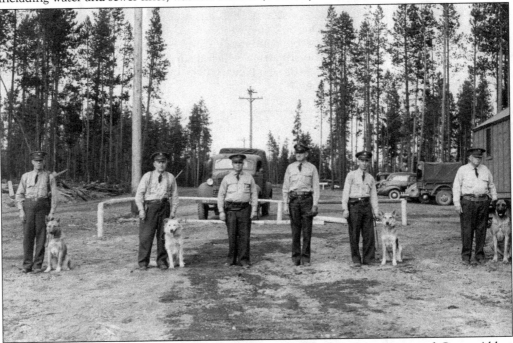

After the departure of US Army personnel, a civilian security force protected Camp Abbot facilities while they awaited dismantling. (Courtesy of DHM.)

Ten

SUNRIVER AND CAMP ABBOT'S LEGACY

After the Army left Camp Abbot in 1944, the property was vacant. Once the war was over, the 5,200 acres of former private lands within the Camp Abbot Military Reservation were offered for sale. Deschutes National Forest lands, which had been included in the reservation, were returned to the US Forest Service.

Immediately after the Army relinquished the property, the Bend Elks baseball team started using the former officers' mess as a summer retreat. The Hudspeth Land and Livestock Company eventually bought the 5,200-acre area of previously private lands for cattle grazing. Colonel Besson's beloved training project, the officers' mess, was used by cattle to get out of the weather and for storing hay. The large property was sold and resold numerous times.

In the early 1960s, the property caught the eye of land developer John Gray and Associates. Gray was interested in turning the property into a planned community and purchased the former Army training area in 1965. A master plan was developed, and in 1968, construction of the lodge and lodge condominiums was underway. A year later, Gray unveiled Sunriver to the public. Several lots were sold, and in 1971, the small community counted 109 residents.

Challenged by a recession and slow sales, Gray sold the property to Connecticut Mutual Insurance Company in 1974. Further sinking in red ink, brought on by the gas crisis of the mid-1970s, Sunriver Properties of Oregon proposed to sell 3,200 acres (58 percent of the area) to the US government for inclusion in the Deschutes National Forest. Federal law prohibited the sale of private land to the US Government without approval from the county government. The Deschutes County commissioners worried that the sale would adversely affect the county's bottom line in the form of lost property taxes, and denied the sale. Eventually, the sale of 2,185 acres to the US government was approved. The sale brought in a much-needed cash infusion of $2.8 million that helped fund future development.

Since then, the former Engineer Replacement Training Center, once known as Camp Abbot, has blossomed into the vibrant residential, recreation, and resort community of Sunriver. At the time of the 2010 census, it was home to 1,393 permanent residents.

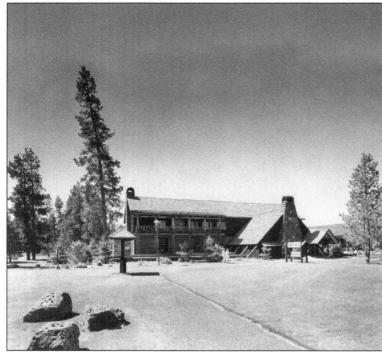

The 50th anniversary of Camp Abbot and the Great Hall—Colonel Besson's beloved officers' mess—was celebrated in 1993. After being left in disrepair for over 20 years, the former officers' mess has been lovingly restored. Now known as the Great Hall, the mountain-style lodge was reopened in 1969. Over the years, it has been the scene of countless weddings, musical events, ceremonies, and grand dinners. (Courtesy of DHM.)

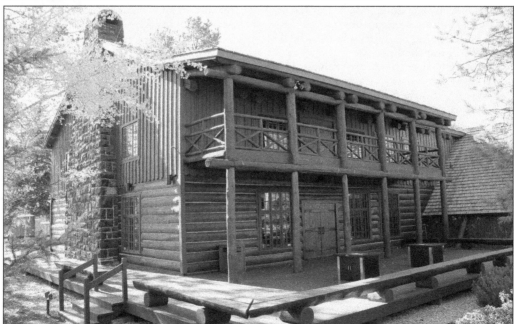

The Great Hall serves as a reminder of the thousands of combat engineers who went through the tough training at Camp Abbot. Although the engineers serving at the camp remembered the officers' mess as an extravagant project, the training project put their skills to the test. When Camp Abbot veteran John Banks returned to Sunriver in 1989, he commented, "It looks better now than when we finished it." (Author's collection.)

The Great Hall has stood the test of time. In all, 63,000-man hours went into building the officers' mess, according to 1st Lt. John Banks, the project engineer in charge of design and construction. A total of 150,000 board feet of timber was used to build the lodge. The grand staircase was constructed using a 465-year-old ponderosa pine. (Author's collection.)

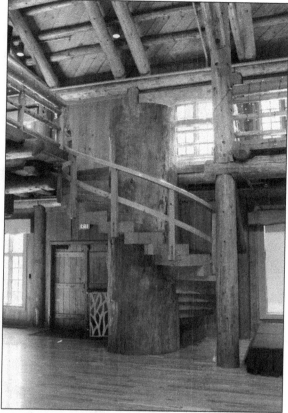

The 50th anniversary of Camp Abbot was celebrated on May 15, 1993. A small contingent of Camp Abbot veterans attended. Invited guests included World War II Medal of Honor recipient Joseph Foss, who did not serve at the ERTC but came close when he was stationed in Klamath Falls for a brief time during the war. (Courtesy of Sunriver Resort.)

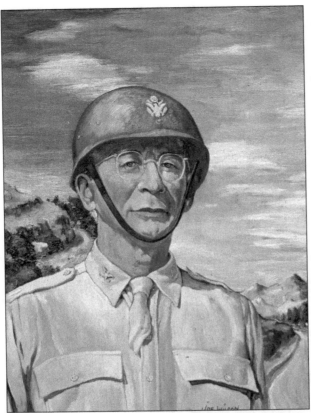

Artist Joe Wilson painted this portrait of Camp Abbot's commanding officer, Col. Frank Besson. According to an article in the *Sunriver Sun* in preparation for the 50th anniversary, the whereabouts of the artist were unknown. Colonel Besson's daughter Jean Adams of Laredo, Texas, said that it was painted sometime during the 14 months Camp Abbot was an active post. (Courtesy of *Sunriver Sun* magazine.)

The portrait graced the walls of the former officers' mess for many years and eventually became the property of one of Colonel Besson's sons, retired Maj. Gen. Frank S. Besson Jr. It was returned to Sunriver in October 1980 during a reunion of Camp Abbot veterans. The ceremony was attended by the retired general, pictured standing to the left of the portrait of his father. (Courtesy of *Sunriver Sun* magazine.)

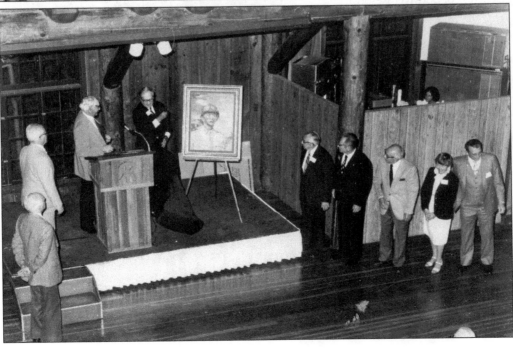

Sunriver Resort commemorates Camp Abbot by naming roads and places after prominent figures from the past. Abbot Drive is Sunriver's primary north-to-south road. The former resort swimming pool is now a small park called Besson Commons. A memorial that fronts this park pays tribute to the camp and its commanding officer. (Author's collection.)

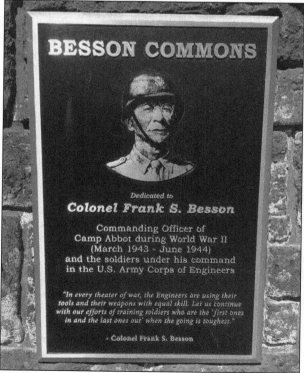

Dedication of the Besson Commons site took place on Saturday, September 7, 2013. Inscribed on the plaque is a quote from Colonel Besson: "In every theater of war, the Engineers are using their tools and their weapons with equal skill. Let us continue with our efforts of training soldiers who are the 'first ones in and the last ones out' when the going is toughest." (Author's collection.)

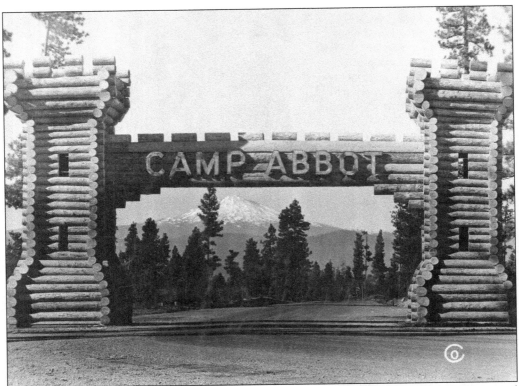

Camp Abbot photographer Dale Vincent spent many days to get the perfect shot of the grand entrance gate, making sure the lighting was perfect to capture both the gate and Bachelor Butte in the background. The structure is long gone, as is the old highway it fronted. The Oregon Department of Transportation realigned The Dalles–California Highway to the current Highway 97 location, west of the original road. (Courtesy of DHM.)

That structure was built to last. Engineers poured cement footings to ensure the heavy structure did not sink into the ground. With a bit of looking, it is possible to see the two cement foundations hidden under pine needles along Forest Road 9720 just east of Highway 97. Central Oregon historian and writer Cmdr. Les Joslin, US Navy, retired, points out the footings of the Camp Abbot log entrance. (Author's collection.)

Among the members of the Women's Army Corps who served at Camp Abbot was Margaret Elizabeth Ann Eller, nicknamed Patti, assigned to the hospital. When Camp Abbot closed, she was reassigned to Madigan Army Hospital at Fort Lewis, Washington, as a laboratory technician.

At Madigan Army Hospital, Eller met Edwin D. "Ed" Graham, also an Army laboratory technician, and married him in 1946. When he retired from the US Forest Service in 1980, Ed and Patti moved to Sunriver, the community built on the site of Camp Abbot. They resided on the site of her former duty station for the rest of their married lives. (Courtesy of *Sunriver Sun* magazine.)

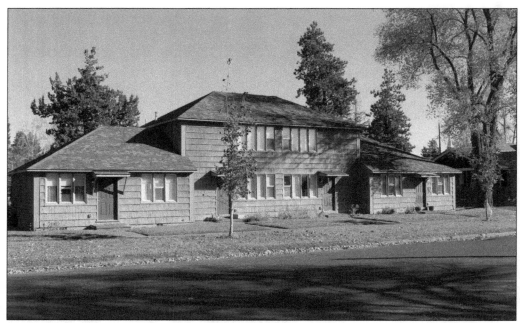

Bend went through a growth spurt during the war brought on by military personnel in need of housing. In August 1943, The US Army approved construction of a 40-unit apartment complex at the intersection of Portland Avenue and West Fifth Street. Portland architects Glenn Stanton and Hollis Johnston were awarded the contract to design the project. James Jansen of Ashland, Oregon, constructed the buildings for $200,000. Each apartment had one or two rooms, a dinette, a kitchen, a living room, and a bath. Appliances included a stove, refrigerator, and heater. The historic apartment complex, called Officers Quarters, remains in use. (Both, author's collection.)

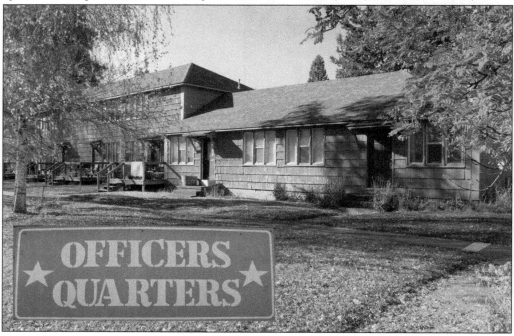

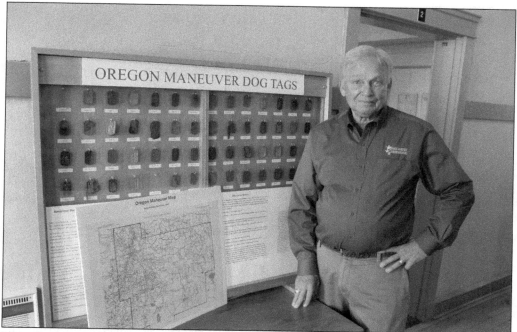

More than seven decades after World War II ended in 1945, the Oregon Maneuver still plays out in Central Oregon's high desert. Even after the Army's clean-up after the war, artifacts remain to be found. The most prevalent findings are identification tags, or dog tags, lost by soldiers who fought in the war game. These are often brought to local area museums, and the largest collection is housed at the Deschutes Historical Museum in Bend. A Bend resident, Lt. Col. Dick Tobiason, US Army, retired, has made it his mission to return these dog tags to the families of men who were involved in the largest military maneuver in Pacific Northwest history. The dog tag below was turned in at the Sunriver Nature Center. (Both, author's collection.)

The USO club was located in downtown Bend at 916 Wall Street. A former Safeway grocery store, it was first used by the US Army as the information office for arriving soldiers and civilians. The Army rented the building with the understanding it would be vacated as soon as Camp Abbot was completed or the USO needed offices of its own. (Author's collection.)

With a few notable exceptions, African American soldiers served in noncombat positions. In contrast to the prevailing attitude in the Army, USO regulations stated that there would be no discrimination based on race, creed, or color. In theory, African American soldiers could attend the main USO club on Wall Street; however, the local USO thought African American soldiers would "appreciate quarters of their own." Their USO extension club was located at 136 Greenwood Avenue. (Author's collection.)

During its 14 months of operation, Camp Abbot featured one main chapel and three auxiliary chapels. The main chapel was spared demolition when the base closed. The congregation of Our Savior's Lutheran Church in Prineville, Oregon, purchased the structure for $1,500 and moved it to the corner of Hardwood Avenue and Third Street in that city. The original chapel has undergone extensive renovations over the years and has been incorporated into the enlarged church buildings. The interior of the chapel has also been modified, and today, little remains of the original Camp Abbot structure. At right, the degree to which diverse faiths were celebrated at Camp Abbot is reflected in the relationship between Maj. William Andrews, a Christian chaplain and ERTC's senior clergyman (left), and Capt. Norman Goldberg, the Jewish chaplain. (Above, author's collection.)

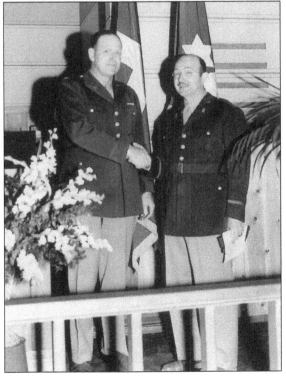

This historic bridge once spanned the Deschutes River about five miles, as the crow flies, west-southwest of Camp Abbot. Begun by the US Forest Service, it was completed by US Army personnel training at Camp Abbot. It was named General Patch Bridge for Gen. Alexander Patch, whose massive autumn 1943 Oregon Maneuver was headquartered at Camp Abbot. (Courtesy of US Forest Service.)

Between the site of the historic General Patch Bridge and the modern Robert D. Maxwell Veterans Memorial Bridge, which eventually replaced it, sits this US Forest Service interpretative sign. It explains that General Patch signed Technician Fifth Grade Maxwell's nomination for the Medal of Honor for valor in combat in France under the general's command. For several years, the general and the soldier had side-by-side bridges. (Courtesy of Les Joslin.)

Many of the photographs featured in this book come from the Halliburton Collection. Staff at Deschutes Historical Museum pooled their own money and bought a collection of over 200 pictures from a collector on eBay. With the help of the collector, the staff tracked down his widow, Margot H. Halliburton, and received her blessing to incorporate the images into the museum's collection. This photograph shows Pvt. Dean Halliburton at Camp Abbot. After receiving his training at the ERTC, Halliburton served with the 103rd Infantry Division in Europe, also known as the Cactus Division. After the war, the division received occupational duties in Germany. While there, Halliburton met his wife-to-be and brought her back to the United States as a war bride. (Courtesy of DHM.)

BIBLIOGRAPHY

The Bend Bulletin. Bend, OR: various issues, 1942–1944.

Coll, Blanche D., Jean E. Keith, and Herbert H. Rosenthal. *The Corps of Engineers: Troops and Equipment*. Washington, DC: US Army Center of Military History, 1988.

The Corps of Engineers of the United States Army: Infantry Journal. Chicago and Washington, DC: Rand McNally & Company/Infantry Journal, 1943.

O'Reilly, Michael. *Camp Abbot: Sunriver's Proud Roots*. Sunriver, OR: Sunriver Nature Center, 1989.

Quinn, James W. *Sunriver: The First 20 Years*. Medford, OR: Commercial Printing Company, 1990.

US War Department. *Pneumatic Pontoon Bridge M3*. Washington, DC: US Government Printing Office, 1943.

INDEX

Abbot, Henry Larcom, 7, 10, 75, 79, 108
Andrews, William, 82, 123
Armstrong, Joyce, 95
Banks, John, 99, 100, 114, 115
Besson Commons, 117
Besson, Frank S., 10, 19, 20, 24, 28, 29, 33, 35, 5
 5, 65, 75–79, 90, 99, 100, 105, 108–111, 113,
 114, 116, 117
Besson, Frank S. Jr., 116
Besson, John, 110
Besson, Robert, 110
Bradley, James, 68
Churchill, Winston, 67
Cook, Gilbert R., 68
Crandall, Frank, 90
Dicey, Robert, 76
Diediker, Paul, 78, 90
Douglas, Clarence J., 21, 30, 90
Eller, Margaret Elizabeth Ann, 119
Goldberg, Norman, 82, 123
Gribskov, Maren, 93
Hannum, Warren T., 14
Harvey, Alfred D., 7, 78

Hayes, Jack, 108
Holman, Rufus, 7, 75
Hudspeth Land and Livestock Company, 113
Joslin, LeCompte, 29, 57, 58, 61, 99, 100, 108
Joslin, Les, 118
Landenberger, Frederick, 17
Louis, Joe, 97
Mature, Victor, 86
McNary, Charles, 7, 75
O'Brien, Paul, 15, 34, 77, 90
Patch, Alexander, 67, 68, 75 111, 124
Ray, Shirley, 93
Reagan, Ronald, 97
Roosevelt, Franklin D., 67
Sawyer, Robert W., 98, 108
Segerstrom, David I., 82
Sturdevant, Clarence, 7, 110
Sunriver Resort, 117
Tiemann, Agho, 86, 108
Tobiason, Dick, 121
Turrill, Russell, 34, 90
Vincent, Dale, 77, 118
Women's Army Corps, 85, 119

Visit us at
arcadiapublishing.com

Printed in the USA
CPSIA information can be obtained
at www.ICGtesting.com
LVHW071458041223
765647LV00008B/141